CHARLES PACHTER

CANADA'S ARTIST

CHARLES PACHTER
CANADA'S ARTIST

LEONARD WISE

Foreword by Tom Smart
Appreciation by Margaret Atwood

DUNDURN
TORONTO

All images © Charles Pachter. Used with permission.
Front and back cover images: © Charles Pachter. Used with permission.
Printer: Friesens

Library and Archives Canada Cataloguing in Publication

Wise, Lenny, author
 Charles Pachter : Canada's artist / Leonard Wise.

Includes bibliographical references and index.
Issued in print and electronic formats.
ISBN 978-1-4597-3874-4 (hardcover).--ISBN 978-1-4597-3875-1 (PDF).--
ISBN 978-1-4597-3876-8 (EPUB)

 1. Pachter, Charles, 1942-. 2. Artists--Canada--Biography.
3. Painters--Canada--Biography. 4. Printmakers--Canada--Biography.
I. Title.

N6549.P32W57 2017 709.2 C2017-901264-9
 C2017-901265-7

1 2 3 4 5 21 20 19 18 17

We acknowledge the support of the **Canada Council for the Arts**, which last year invested $153 million to bring the arts to Canadians throughout the country, and the **Ontario Arts Council** for our publishing program. We also acknowledge the financial support of the **Government of Ontario**, through the **Ontario Book Publishing Tax Credit** and the **Ontario Media Development Corporation**, and the **Government of Canada**.

Nous remercions le **Conseil des arts du Canada** de son soutien. L'an dernier, le Conseil a investi 153 millions de dollars pour mettre de l'art dans la vie des Canadiennes et des Canadiens de tout le pays.

Care has been taken to trace the ownership of copyright material used in this book. The author and the publisher welcome any information enabling them to rectify any references or credits in subsequent editions.

— *J. Kirk Howard, President*

The publisher is not responsible for websites or their content unless they are owned by the publisher.

Printed and bound in Canada.

VISIT US AT

dundurn.com | @dundurnpress | dundurnpress | dundurnpress

Dundurn
3 Church Street, Suite 500
Toronto, Ontario, Canada
M5E 1M2

For Charles Stuart Pachter

CONTENTS

FOREWORD

by Tom Smart

"Moose Factory" is comfortably tucked between two century-old houses in a tiny urban enclave in the shadow of Toronto's Art Gallery of Ontario. Its cantilevered, glass-curtained second floor gallery juts out into the shady avenue like a chin. The odd modern incarnation of the building, the history of which includes spells as a food warehouse and a turn-of-the-century funeral parlour, is one of two homes and studios of Charles Pachter, artist and self-styled Canadian icon.

His second home is "MOFO" (Moose Factory of Orillia), which is more in the character of a growing compound of studios, a gallery and living quarters on the edge of the downtown blocks of Orillia, Ontario. Pachter is developing this once-forlorn neighbourhood as an expression of his big vision to incubate a rural artistic institute on Lake Simcoe, beyond the hubbub of the big city.

Urban and rural, modernist and iconoclast, colourist, and imagist, Pachter is an artist of many paradoxes. Painter, printmaker, sculptor, and designer, he has been a significant contributor to the Canadian art scene for over half a century. His distinctive, highly accessible art is woven into the very fabric of his country's iconography and public consciousness. Pachter's emblematic images are represented in public and private collections; his ubiquitous moose-crossing road signs can be seen along highways and roads across northern Ontario.

Pachter has always demonstrated a remarkable ability to be ahead of the times in anticipating cultural movements and developing local art scenes. From *The Other Shaw Festival*, the Artists Alliance, and the Artery in the 1970s and 1980s, to the many projects that kick-started the urban development of Queen Street West as an artistic

nexus, he has always displayed a prescience for identifying trends early on and for nurturing creative opportunities that have benefited artists and communities enormously.

Well trained as an art student at Michigan's Cranbrook Academy, Pachter brought a unique frame of reference to his way of seeing the world and making images, spanning two countries. His personal mode of representation also flew in the face of the tremendous forces of abstraction and minimalism that held sway in the art world when he was starting out as a professional artist in the 1960s.

He entered the art world at a time when imagery was being stripped from canvases, replaced with spare, colour-saturated surfaces and self-referential meaning. Pachter was and remains a bold imagist, a poetic painter. Through radical juxtapositions and dynamic arrangements of colours, and through his deeply literate and visual sensibilities, Pachter adapted an expressive strategy that was analogous to what our best poets and novelists at the same time were doing in words.

In his creative collaborations with Margaret Atwood we can see how closely aligned painting is to poetry, and how the language of one can broaden the vocabulary of the other in ways that expose foundational common truths that animate both creative forms. "As is poetry, so is painting" could be Pachter's artistic motto.

An unashamed royalist, Pachter is also best known for his affectionate portraits of the queen. The most well known are the humorous, notorious paintings of Her Majesty sitting astride a moose. They created a stir when first exhibited more than three decades ago, yet these anachronistic images have endured and even multiplied with successive additions to the royal family. They are etched in some deep part of my consciousness, informing the way I see the world and my country. In broad strokes, Pachter's art conveys the signs and symbols that form the strangely diverse mosaic of Canadian identity.

The portrait Leonard Wise paints of Charles Pachter in this book, often using the words of others, is of a passionate, impatient, and, at times, irreverent man whose creative impulse extends from finding — in the life around him, in his history and his community's roots, and in the defining principles of his country — evidence of the fundamental stories that make us human: myths. He plumbs life and recreates it as art in all its comedy and tragedy, romance and sadness. For Pachter, life has an operatic dimension. He is a mythologist, devoting his considerable skills to shaking things up with grand gestures, profound feelings, sensual overloads, and glorious, splendid expressions of being human.

Importantly, what comes through in this collage of biography and commentary is essentially a realization that Pachter is a nationalist, perhaps even, as Wise says,

"Canada's artist." This quality of the man and the artist renders him, in my mind, one of our most compelling citizens. The startling, unusual, and beautiful visual metaphors comprising his expressive portfolio make me want to look deeply and patiently at his art, and to luxuriate in its resonance and sensuality. In his compositions' strange, jarring juxtapositions, the intently probing nuances of his visual acumen, and in the controlled blending of impatience with complacency, Pachter compels me to find new ways to see the landscape and people around me in the roiling, odd, and frequently confusing place we call Canada.

The power and paradox of Pachter's art rests in the way you sense a national character simply by standing in front of one of his paintings, prints, or sculptures. Against all efforts to challenge and confront what is before my eyes, I sense that a stealthy spirit animates the surfaces of his art, as if conjured in the stuff of their making, but emanating like a polychromed ghost in front of me. It is a spectre as old as the land I am standing on, or the factory/house/funeral home I am lingering in.

I am often startled to find myself in one of Pachter's worlds, and for those moments I come to appreciate in a deep way this gregarious, talented man's art. Pachter's wide-spectrum personality; profoundly rich poetic, visual imagination; passionate embrace of what it can mean to be human; engaged citizenship; and raucous humour are all on full display in this book.

Tom Smart
Art Gallery Curator, Peel Art Gallery, Museum & Archives
Former Executive Director, McMichael Canadian Art Collection
Former Curator, Winnipeg Art Gallery
Former Head of Collections and Exhibitions, Frick Art and Historical Center

February 18, 2017

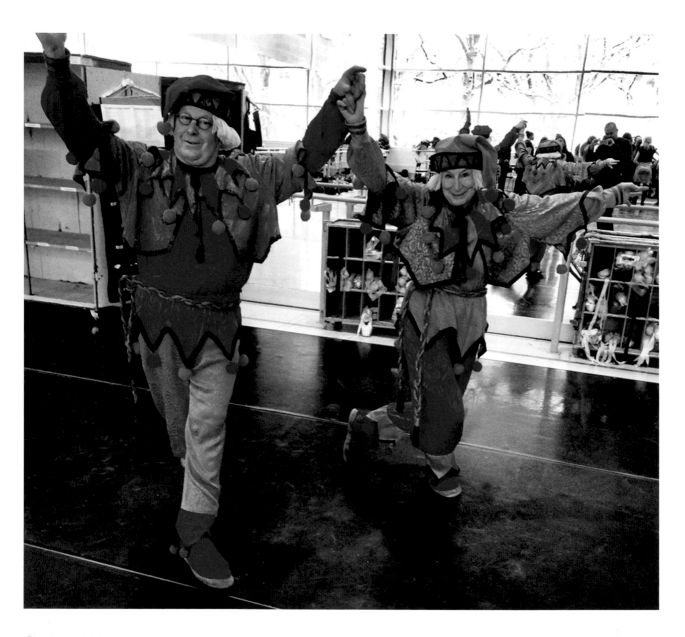

Charles and Margaret
as Cannon Dolls in the
National Ballet's production
of *The Nutcracker*,
December 2016.

(Photo — Keith Lem.)

APPRECIATION

by Margaret Atwood

Originally published as the foreword to Bogomila Welsh-Ovcharov's monograph *Charles Pachter* (Toronto: McClelland & Stewart, 1992).

I am a writer, rather than a painter or an art historian, so my introduction to this book must be, of necessity, personal rather than professional, informal rather than formal. I can only see Charles Pachter in the contexts in which I have been associated with him: as a sometime collaborator, and as a long-time friend.

I first met Charles Pachter in the summer of 1959, at Camp White Pine in the Haliburton region of Ontario. I was nineteen, and had been hired to set up a nature program at this camp. Charles was sixteen, and was assistant to the arts and crafts director. I was already viewing myself as a writer, and had begun publishing my poetry; Charles himself was on the verge of recognizing his vocation as an artist. He claims I beckoned him over to the "nature hut" — which was, at that time, a dank, converted tool shed — to demonstrate to him that stroking a toad would not give him warts. I do not remember this, but recall instead his energy and inventiveness during arts and crafts workshops. In any case, this phase of my life was later to be incarnated as a Pachter serigraph image, complete with insect-eye sunglasses and green and orange butterfly wings, holding a caterpillar and smiling enigmatically. Our friendship, which led to our later collaboration, was bizarre but inevitable, and has remained so ever since.

Since Charles Pachter spent his formative years in a particular place at a particular time, I should say a little about Camp White Pine itself, and a little too about Canada as an artistic environment in the fifties.

White Pine was, and still is, a liberal Jewish co-educational summer camp. At that time it specialized, not in knot-tying and strenuous canoe-tripping of other more traditional camps, but in the development of social awareness. The themes of its five-day special programs were likely to be The Brotherhood of Man in one form or another; many of the songs were earnest variants of "No Man Is an Island." But at the same time, there was a heavy unofficial emphasis on parody and satire. Jokes and practical jokes abounded, skits and mockery were endemic, and no theory or pretension was too lofty to be punctured. In both these tendencies — the well-meaning idealism and the parody — White Pine was perhaps a condensed microcosm of which Canada was the macrocosm. *Who Do You Think You Are?* is the title of one of Alice Munro's short story collectives, and no Canadian needs to ask for a translation, because we have all had this indignant and scornful question addressed to us at some point in our lives, when others thought we were getting too big for our boots.

This satirical or parodic mental tendency has been expressed by Pachter in lighthearted ways — his takeoff on the art world in 1975, *The Ugly Show*, his commentary on Toronto interior furnishings, which he reproduced tongue-in-cheek in his one-time restaurant, Gracie's — but it is also reflected in many of the titles of his serious work. He is capable of constructing a mysterious and beautiful image — of, for instance, an orange sofa floating in front of a window that frames a Georgian Bay windscape — and then undercutting it by calling it *Davenport and Bay*, a play on words which incorporates two Toronto street names. In many countries, you would not be taken seriously if you did this kind of thing. In Canada, paradoxically, it's difficult to be taken seriously, in the long run, unless you do this kind of thing; not exclusively, but from time to time, just to show you aren't too full of yourself. Self-mockery is *de rigueur*. Thus one of Pachter's most intense and brooding images is titled *Life Is Not a Fountain*, a double-bladed and poignant reference to the punch line of a well-known shaggy dog joke.

But anyone who came of age as an artist in Canada of the fifties and early sixties had need of some form of defensive armour. Painting, or the pursuit of any art, particularly in middle-class households such as the one Pachter grew up in, was not considered a suitable occupation for anyone, and especially not for men. The number of young people interested in the arts, even at university, was relatively small, and we tended to stick together and to support one another. The culture as a whole

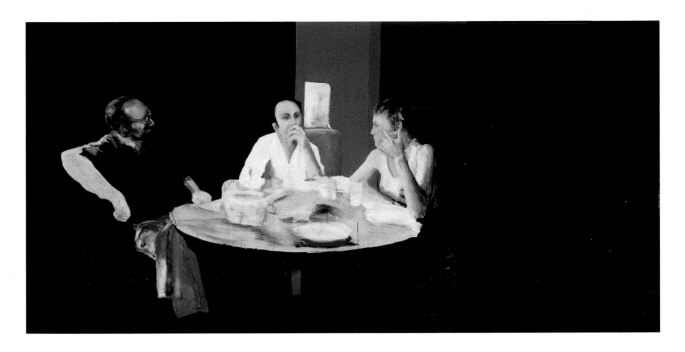

still retained its frontier-society distrust of the intangible and the impractical and its provincial conviction that art, if it had to be done at all, was done better elsewhere, preferably by dead Europeans. On the positive side, however, the absence of any weighty and ever-present artistic tradition created a vacuum, into which young painters could move fairly easily without feeling they were challenging Michelangelo.

By the fifties the centre of gravity for many Canadian painters had shifted from their own national ground, occupied during the twenties and thirties by the Group of Seven and their associates, to the Abstract Expressionism of New York (a direction Pachter never pursued). There was, however, a popularly accessible, highly visible tradition in painting: a Group of Seven serigraph reproduction hung in practically every bank and school — a wild and dangerous landscape tamed by a frame — along with the obligatory portrait of the queen. The appearance of these two groups of images in Pachter's later work, and his exploration of their incongruity when juxtaposed, is not arbitrary: both the queen and the Group of Seven landscape formed an integral part of his earliest visual vocabulary, as they did for all Canadians of that generation. Both groups of images call up, for many Canadians, something like a collective memory, a deeply inscribed dream.

Pachter's interest in the transmutation of popular icons — the flag, the Toronto streetcar, the queen, the moose (and others which appear less frequently in his work,

Life Is Not a Fountain, acrylic on canvas, 1976.

(Private collection, Zurich.)

such as the pope, the Supreme Court judges, Barbara Ann Scott, the hockey player, and the Ontario butter tart) — has often been commented on, but few have explored its roots in his early life. Pachter has long had a sense of double identity, linked to the fact that he did not fully realize that the family was Jewish until he was six. Thus his perspective has been that of the insider, so "inside" Canadian culture that he was chosen to represent Canadian youth in a National Film Board documentary about the Canadian National Exhibition, and met both Barbara Ann Scott and his first moose at the age of four. But it has also been that of the outsider, peering at the "official" cultural life of Canada through ethnic-tinted glasses and sensing the threat to himself inherent in a version of reality that did not necessarily stamp him with a seal of approval. Driven perhaps by a desire to enter and possess forbidden territory which he sensed was already his, Pachter has been a tireless explorer of Canadian history, both local and general. He knows Toronto thoroughly, in all three of its special dimensions and in its fourth dimension, time; he unearths old journals and recreates nearly forgotten historical figures such as Governor and Mrs. Simcoe and the early settlers of the region. He has always wanted to know what is behind, before, and underneath perceived reality.

The recognition of the gap between smooth presentation and dangerous, complex reality is not, of course, unique to Pachter; it is omnipresent in Canadian literature, and has been explored with special ingenuity in the work of writers from southern Ontario — Pachter's heartland — such as Robertson Davies, Alice Munro, James Reaney, Graeme Gibson, Marian Engel, and Timothy Findley. It's no accident that this culture produced Mackenzie King, a prime minister noted during his lifetime for his intense blandness and celebrated after it for the fact that he was discovered to have been ruling the country through his dog, whom he thought contained the spirit of his dead mother. It's no accident either that it produced Pachter. Alice Munro speaks of the lives of ordinary people as "deep caves paved with kitchen linoleum."[1] In many of his images drawn from observed life, such as his early "family" series of serigraphs and some of his later portraits, Pachter depicts the linoleum, but also implies the caves.

This is the environment in which Pachter grew up, then: a Canada noted for its niceness, a bland surface which concealed a wildness, a Gothic weirdness, even a menace. Any Canadian looking at Pachter's seemingly pastoral sunbathers on a beach, their backs turned to the viewer, their eyes fixed on an endless level blue expanse of water, knows that under the surface of the lake there's someone drowning; as indeed there is, every summer.

Pachter's conscious exploration of the visual symbolism that surrounded him began, long before the ascendancy of Andy Warhol, when as a teenager he painted the

landscape from a two-dollar bill on his bedroom wall, much to the bewilderment of his mother. It was reinforced by the early work of Marshall McLuhan, who had published his classic examination of symbolism in visual advertising, *The Mechanical Bride*, by the time Pachter had reached university. This book was withdrawn from circulation at the insistence of several companies whose ads McLuhan had reproduced in it, but you could buy copies of it direct from the maestro, who kept them in his cellar. I had one, and showed it to Pachter at the time. He had a natural curiosity about advertising, which a number of us shared — we were, after all, bombarded with it from morning to night — but McLuhan helped us to look at it in a more speculative way. For Pachter the results of this influence were specific, as in his lithograph of a woman's love affair with her hot-water heater, but also more general. Throughout his career he has shown a receptiveness and a sensitivity to visual images of all sorts, whether they originate in the world of art or on a streetside hoarding. His subway mural of the Toronto Maple Leafs and the Montreal Canadiens (*Hockey Knights in Canada*) and his Acme Bar and Grill mural (*Voice of Culture*) are the latest products of this visual cross-pollination.

My own collaboration with Charles Pachter developed slowly and without pre-meditation. By 1960, when I was in my third year at university, Pachter had entered the same university, in Art and Archeology. We had just spent another summer at Camp White Pine — a summer which, as I recall, we ended by hiding under the cabin floors of some visiting city slickers and howling like wolverines — and we continued to see one another. I had at that time a small silkscreen poster business, and it was this equipment that eventually ended up in Pachter's hands some time after I graduated, and with which he produced an early set of serigraphs. We continued to correspond through these years, while he was in Paris and Toronto and later at the Cranbrook Academy of Art in Michigan, while I was at Harvard or teaching at the University of British Columbia.

The Circle Game, his first limited-edition folio, illustrated a group of poems I had just completed, and which I'd sent to him rather casually in a letter, after he'd written saying he'd like to take a crack at illustrating something. We were both so excited by their results that we went on to do several other collaborations, including his astonishing *Speeches for Dr. Frankenstein* and eventually, the monumental *Journals of Susanna Moodie*. Pachter was eccentric among artists of his generation, for whom a studied non-literacy was the social norm, in that he permitted himself a lively verbal dimension and allowed his imagination to be accessible to verbal imagery. His procedure when he created a book, using either my poems or those of somebody else such as Alden Nowlan, John Newlove, or Dennis Lee, was to immerse himself in the texture

of the poetry itself for weeks, exploring its possible meanings and directions and leaving himself open to its suggestions, before starting to create his visual images. What he was able to produce was neither simple-minded illustration nor a juxtaposition of words and unrelated visual work, but an interaction between text and image that is unusual in the field.

Since that time, in a career which has now lasted three decades, Pachter has continued vigorously to explore his several media, to diversify his imagery, and to structure and restructure his visual world. In doing so he has restructured the world around him, and has changed profoundly the way we look at our own familiar iconography, even our own banalities. His output has been immense, his wit and versatility have remained constant, and his range continues to broaden. His is a sophisticated art which draws upon many techniques and evokes many echoes, yet it remains strongly individual, and firmly rooted in a ground which Pachter has both excavated and cultivated himself.

Margaret Atwood
Best-selling author of *The Edible Woman,*
The Handmaid's Tale, and *Oryx and Crake*

INTRODUCTION

"What is the point of reading biographies of artists?" asked Deborah Solomon in her *New York Times* review (December 2, 2015) of Julian Barnes's *Keeping an Eye Open: Essays on Art*. Coral Ann Howells, in *The Cambridge Companion to Margaret Atwood*, remarks that "biography is the making of pâté from the duck." Is it possible for an entire life to be contained within a book of a couple hundred pages? How does one write someone's biography when they're not even dead yet? Solomon suggests that "the details of a life are helpless to explain the majesty of art."

So the question remains: Should we try to separate the artist from the art?

What matters, Solomon contends, "are not the despairing childhoods and difficult relationships" — whether a particular artist was altruistic like Cézanne, or plainly cruel like Picasso, or publicity-seeking like Warhol — but "the object that emerged in the end, an object unburdened by life, succeeding or failing on the basis of its appeal to the eye." Yet, she also admits that "biographies of artists offer us a chance to view a life from all sides, to be moved not only by triumphant masterworks but by the stirring efforts underlying even the supposed duds."

Jacques Barzun, in his book *The Modern Researcher*, tells us that "biography gives us vicarious experience." Whether you admire or revile their subjects, biographies can inspire us, encourage us to dream, and, at minimum, let us see how others handled the trials and tribulations of life.

Meanwhile, in *Michel Foucault and Theology*, a book by James Bernauer and Jeremy Carrette, Foucault is quoted as saying, "We need biography as we need history, in order to dispel the chimeras of the origin. We use biography for its jolts, its

surprises, its unsteady victories and unpalatable defeats." It is usually argued that the point of a work of art is not to learn about the artist but to have an aesthetic experience, regardless of the artist's intentions. However, information from an artist's life can sometimes help us understand the meaning of their art.

Charles Pachter emerged as an artist in a country that was previously inhibited by colonial insecurities, a country that gradually grew into a new era of nationalistic pride and confidence. The Canada in which Pachter has worked all of his life is one that, save for a few exceptions, does not celebrate its living artists. It is also a country with a tight and exclusive arts bureaucracy, one that offers little room for or support of artists that don't play by its rules. Despite this, Pachter has consistently created works that communicate joy and passion, along with humour and a great pride in Canada. It is a body of work of immense achievement.

When we look at his art, though, few bother to appreciate the articulate genius behind his wisecracking facade, or to think about the psychological burden he has had to endure from years of rejection by government granting institutions, curators, art critics, and members of the art establishment. The works succeed or fail by themselves, of course, but knowing the context in which they were created lends greater resonance to them.

Charles's struggles to survive and thrive as an artist are ones that he shares with other artists, too. The fracturing of relationships and the forfeiture of any semblance of normal life are common occurrences for many artists. Few readers ponder their sacrifices — the sleepless nights; the years spent alone, painting when depressed, when elated; the self-promoting; the need to be constantly socializing, networking, trying to sell.

Of course, Charles is by no means the only successful self-promoter in the art world. Gustave Courbet was a great painter, but he was also a serious publicity seeker. So was Salvador Dali, and so is Jeff Koons. Andy Warhol was another big self-promoter; he felt that being good in business was the most fascinating kind of art, and that making money is art and good business acumen is the best art.

After decades without any official recognition or support, Pachter began to finally receive acknowledgement for his achievements in the 1990s. One of the highlights of his life was the year he received an honorary doctorate from Brock University in 1996.

The media release stated, "In the 1960s he completed his undergraduate education in Toronto, where his parents hoped he would pass on being an artist and become a doctor." Finally he had become one.

In his honour, Atwood sent him the following ode:

> The Life of Charles
> (short version)
>
> There once was a young man named Pachter
> in whose life fine art was a factor
> He painted and painted
> until he was sainted
> by an honorary degree for which
> we shout congracht[1]

In 1999 Charles became a Member of the Order of Canada at an elegant ceremony in Rideau Hall in Ottawa. The award was itself a great honour, of course, but the whole thing was made sweeter by the fact that Governor General Adrienne Clarkson, an old friend, bestowed it on him. She congratulated Charles before the crowd, and then, knowing how much the award also meant to him, said, "I'm so glad you were able to bring your mother."

Thirteen years later he was promoted to Officer of the Order of Canada. Letters of congratulations arrived from Shirley Thomson, head of the Canada Council, an organization that had turned him down a dozen times for a grant, and Matthew Teitelbaum, the director of the Art Gallery of Ontario, an institution that has yet to purchase any of his work.

In 2009 Pachter received an honorary doctorate from OCAD University, and a year later another one, this time from his alma mater, the University of Toronto. Following Pachter's acceptance speech, Chancellor David Peterson told him, "Charles, you gave the best speech I have ever heard at a commencement."

How I Met Charlie

In September 1969 I was at a friend's house in Rosedale. I bumped into Charlie Pachter, a twenty-seven-year-old artist who'd already had two solo exhibitions. He was talkative and amusing, attracting attention with his wit and his storytelling. At

that time he was living in a house he had just purchased on Shaw Street, where he was building a printmaking studio.

His creative enthusiasm about everything was infectious. Somehow we became friends. Over the next forty-seven years I got invited to his parties and exhibitions, met his friends, and watched collectors acquire his paintings. My wife, Sandy, and I were also guests at his winter home in Miami Beach and at his summer home in Orillia.

What's he like? Well, for starters, he's generous, loving, non-judgmental, sensitive, articulate, quixotic, cheeky, mercurial, capricious, and roguish. He's also self-centred, and has a tendency to tell tasteless jokes — though he does so with great timing. A natural entertainer, he likes working a crowd, and he is a gifted raconteur, a historian, and an outstanding public speaker. He's also an insightful architectural designer and developer, entrepreneur, promoter, bargain hunter, and negotiator. In short, he's a Renaissance man. But the most remarkable feature about him, according to those who know him well, is that his kindness is boundless. His generosity is unsurpassed, whether it's the artworks he gives to charities or the use of his home and studio that he freely provides for fundraising events.

Paradox defines him:

1. His studio is messy, and his clothes are often paint-spattered, but his living space is spotless (thanks to Guida, who has been his faithful cleaning lady for years).
2. He's happiest when he is surrounded by people, and he's happiest when he is by himself.
3. He's a monarchist who loves royalty, yet he delights in satirizing them.

I was given the opportunity to write this book after I dropped in on Charlie a few months ago and he asked, "What are you doing these days?"

Having retired as a lawyer, I mentioned that I was now writing memoirs for various individuals. That prompted him to phone Kirk Howard, publisher at Dundurn Press, to inquire, "Are you still interested in publishing my biography, because if you are I may have a writer for you."

Kirk's response was simple: "If you want him to write it, then so do I."

And so began the process of my researching Charlie's life.

One of the things that made this easy (and difficult) is the fact that Charlie is a pack rat. He keeps a copy of almost everything he's done, said, or thought,

including records of almost everyone he's ever met. So there was a great deal of material to look through.

His papers are now in the archives at the Thomas Fisher Rare Book Library at the University of Toronto. I spent my first few weeks working on the book there, poring through seventy boxes of Pachter lore, from his Grade 1 report card, to letters from camp that he wrote to his parents, to the voluminous correspondence between him and Margaret Atwood, whom he has known since they were teenagers.

I had the great pleasure of interviewing fifty of his friends, some of the most interesting people I have ever met. I particularly enjoyed the mischief of John Fraser, the erudition of Michael Marrus, the graciousness of Marcia McClung, the wit of Rosie Abella, the thoughtfulness of Rick Salutin, and the penetrating insights of Margaret Atwood. I chatted with eighty-nine-year-old Norman Jewison and was treated to lunch by philanthropist Nona Heaslip.

I watched Charlie give a funny, informative speech to one hundred elderly monarchists at the Canadian Royal Heritage Trust dinner at Wycliffe College in the University of Toronto about the creation of the Town of York by Ontario's first lieutenant-governor, John Graves Simcoe.

A day in the life of Charlie, assuming you can keep up with him, entails following him on Dundas Street as he heads for Dim Sum King, one of his favourite Chinese restaurants, where the waiters call out to him "You VIP!" and where everyone seems to know him.

Being at home with him is like living in a circus. The phone rings, the email pings, the doorbell dings, and people come and go. An emerging artist asks him for a critique of his work, a lady solicits a donation of his art for her charity, and another wants to reminisce about the old days on Queen Street. And on it goes. He donates his artworks to fifty charities a year, gets fifty emails a day, spends three hours a day on the computer, and has 4,500 followers on Facebook.

Nowadays, at age seventy-four, Charlie is still on a roll, selling his work to serious collectors, and, totally unexpectedly, finding a life partner. He has built a second home and studio in Orillia, and he envisions a major cultural arts campus there on the site of the former Huronia Regional Centre. As many have noticed, he's never been happier.

Welcome to *Charles Pachter: Canada's Artist.*

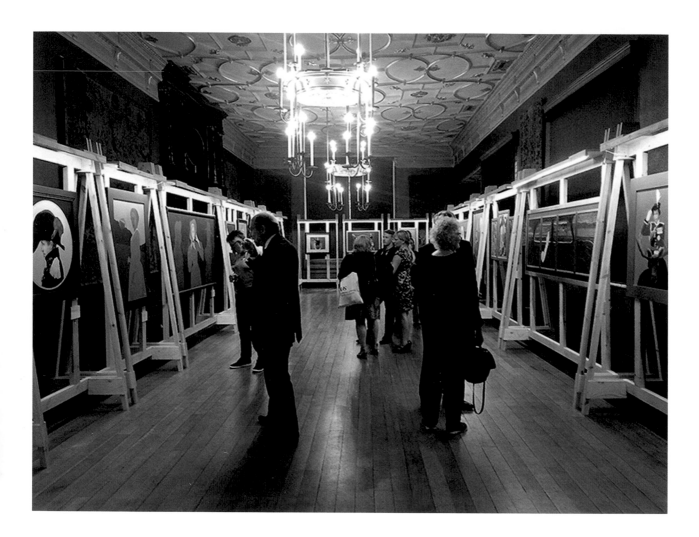

Charles Pachter
exhibition in the
Throne Room of the
Charterhouse, London,
August 2016.

London, August 2016

On a six-acre site in the heart of London, England, there once stood a medieval monastery. Built in 1381, it was visited by Thomas More for spiritual recuperation, employed by Henry VIII to store his hunting equipment, and demolished by Sir Edward North in 1545 so that he could transform it into a luxurious mansion house, known today as the Charterhouse. Used by Queen Elizabeth I in 1558 to prepare for her coronation, 458 years later it was the site of a solo exhibition by one of Canada's best-known artists, Charles Pachter.

On opening night, August 18, 2016, aristocrats and commoners, academics and art lovers alike, gathered in the Charterhouse's chapel to hear speeches celebrating Pachter's career by Hal Jackman, Ontario's former lieutenant-governor; John Fraser, the former Master of Massey College in Toronto; and Katerina Atanassova, curator of Canadian Art at Ottawa's National Gallery. The recipient of three honorary doctorates, an Officer of the Order of Canada, and a member of the Order of Ontario, Charles has met the queen and had a major exhibition of his work in London, England. At age seventy-four, Charles Pachter has had quite a journey.

CHAPTER 1

Childhood

Charles Stuart Pachter was born prematurely at Toronto General Hospital on the night of December 30, 1942, during the Second World War. Charles has an older sister, Maida, born on April 13, 1941; a younger sister, Karen, born on November 20, 1946; as well as a younger brother, David, born on August 20, 1948.

Charles's name was an anglicized version of both of his deceased grandfathers' names. One reason his parents may have decided on an English name was in honour of Bonnie Prince Charlie; another was because they thought Hitler might make it to Toronto. It was, after all, 1942, the year Jews were being deported to Auschwitz. Whatever the reason, the name stuck. The family has always referred to him, and continues to refer to him, as Charles; although, most of his friends have called him Charlie since high school.

Both of his grandfathers died in their fifties before he was born, but Charles was told that his maternal grandfather was scholarly, rebellious, and determinedly anti-religious — traits that Charles cherishes.

His grandmothers were feisty characters — hardworking, funny, and the source of much mirth with their broken English, picturesque phrases, and old country sensibilities. One winter, for example, his maternal grandmother,

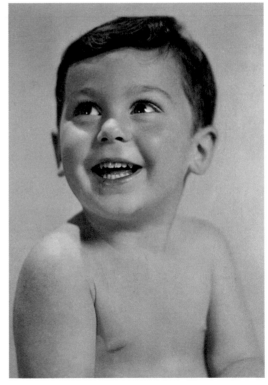

Charles, age 2, 1944.

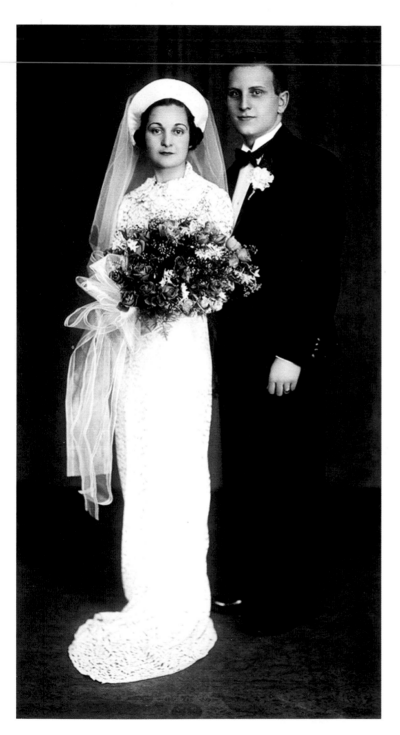

Wedding portrait of Sara and Harry Pachter, January 1937.

Eva, announced matter-of-factly, that the unseasonably warm weather was due to "a general toe." After some linguistic sleuthing, the family determined what she meant was "a January thaw." Another time, she came home from selling her wares in Port Credit and asked her kids what a "bleddehyoo" was. Wondering what she meant, they asked her to explain. She told them she had sold a black half-slip to a woman whose husband had come home drunk, and called her "a bloody whore."

Charles's parents, Sara and Harry Pachter, were both Canadian-born and grew up in Toronto during the Depression.

When one of Sara's brothers died of tuberculosis in 1922, the family moved from Edmonton, where they had been living, to Toronto where a cousin had a shoe repair shop on Queen Street East. Sara's father opened a cobbler's shop at 768 Yonge Street, which later became the Loew's Uptown Theatre, now long gone. Her mother, widowed at thirty-five with four children, became a door-to-door peddler of dry goods that she bought wholesale on Spadina Avenue and sold in Port Credit.

Harry was born on March 11, 1914, on Peter Street in downtown Toronto, just north of the present-day Rogers Centre. He attended Sir Charles G.D. Fraser School.

A cousin introduced Sara and Harry at a party in Toronto in 1936. They were married in January 1937. After their marriage they eventually moved to a flat at 499 Palmerston Boulevard, where Charles was born.

His parents weren't particularly religious, and the house where he grew up, at 84 Chudleigh Avenue in north Toronto, was in a neighbourhood inhabited mostly by middle-class Anglicans. His childhood playmates were well-brought-up little WASP and Catholic boys and girls, with names like Johnny, Gail, Betty, and Jeannie.

Johnny Macfarlane, who would grow up to be John Macfarlane — the respected magazine and book publisher — was Charles's next-door neighbour. Macfarlane lived there with his divorced mom and his grandmother, who, thinking she was a coloratura soprano, spent humid summer afternoons at her piano practising operatic scales. Johnny and Charles, both four at the time, used to stand outside under her window howling like little coyotes whenever she sang a scale, then they would collapse laughing until she poured a bucket of water over their heads to shoo them away.

"Charles was my favourite of all the kids I knew then," recalled John.

Charles didn't really grasp what being Jewish meant until he turned six, according to his long-time friend, Margaret Atwood. When he was four, his babysitter, Mrs. Rupert, a Baptist holy roller, taught him to pray and roll at the same time while chanting, "Now I lay me down to sleep, I pray the Lord my soul to keep. If I die before I wake, I pray the Lord my soul to take." Not your typical Jewish prayer!

On Sunday evenings, after supper of peanut-butter-and-bacon sandwiches on brown bread at Johnny's house next door, the two of them usually went to the basement of the local Catholic church to watch flickering black-and-white "Prince of Peace" movies, starring Jesus, dressed in a long white nightie with rope belt and sandals, his stringy hair parted down the middle, his aquiline nose highlighted by makeup. The kids would also sneak into the church where there were niches with statues of the Virgin Mary and the Annunciation. On the floor of the basement were little blue and red plastic chips, which they collected. For years Charles thought bingo was a Catholic ritual.

To this day he can still remember being bullied by a bunch of bigger kids when he was four and locked under Lawrence Park Collegiate stadium where concrete bleachers were being built. He will never forget the smell of the curing concrete, straw and mud, and the echo of dripping water in the pitch-black as he waited, terrified, to be rescued. Another time when he bragged to the other kids that Jesus was Jewish, he got beaten up and called "a dirty Jew." He asked another babysitter, Mrs. Decker, if he was "a dirty Jew," and she replied in her thick Scottish accent, "I wouldn't know, dear, I'm not Jooweesh."

One day he came home and asked his parents, "Why don't we have a picture of the Baby Jesus in our house like all the other kids?" Another time he came home with a Gideon Bible he had signed in school, confessing that he was "a sinner in the eyes of Jesus Christ, our Lord." On each occasion Sara looked at her husband and said, "Harry, say something!"

Feeling they should help their kids discover their Jewish identity, Harry and Sara decided to enrol five-year-old Charles and his older sister Maida in religious school at the Holy Blossom Temple because, as his father later admitted, theirs was the cheapest membership fee of the new synagogues being built in the then-suburbs around Eglinton and Bathurst. After being "consecrated," Charles came home with drawings he had done of Jonah and the whale and Elijah riding a flaming chariot.

In fact, Charles's artistic inclinations were evident from the time he was a baby. One night when his parents returned home from a movie, they found his distraught babysitter cleaning the wall beside his crib. Charles had gleefully used the contents of his diaper to create his first mural.

At age four he made a papier mâché duck from newspaper strips and flour paste, and he placed it beside the furnace to dry. When he awoke the next morning, he was traumatized to find that it had disappeared. Thinking it was a piece of trash, his mother had thrown it out. Charles was inconsolable and cried his eyes out, despite Sara telling him, "You can always make another one."

The remarkable event that shaped his later life, and made him into a celebrity at age four, happened in the summer of 1947. His father's sister, Aunt Ruth, heard on the radio that the National Film Board was looking for a kid to play a lost boy in *Johnny at the Fair*, a film about the Canadian National Exhibition. After six years of being used as a military supply base during World War II, the "Ex" was now being groomed to reopen. Ruth told Sara that the NFB was auditioning kids that very afternoon in a last-minute effort to find the right "Johnny." Charles was soon on a streetcar with his mom, heading down to the CBC for a three-minute interview with the director, Jack Olsen. A precocious, fearless little kid, Charles picked his nose and did somersaults while the director sat behind a desk watching. Afterward, mother and son took a cab home.

Back at the house they found reporters and cameramen already on their front lawn, flashbulbs popping, and his mother was being asked for interviews by the

media. A few days later the papers were full of stories with headlines like: "Boy Born Since CNE Closed Chosen For Role In 'Ex' Film" and "Impressionable Extrovert Wins Sonny Movie Role." For the next two weeks Charles was awakened early each day, dressed in the same striped T-shirt and brown shorts, and driven down to the Ex in a Chrysler woodie wagon convertible. Let loose to roam the midway and the Exhibition buildings, he jumped on the rides, took a flight on a helicopter, ate taffy apples, tasted candy floss, and chewed gum while the director, camera crew, and press followed his every step.

It all seemed glamorous, a topsy-turvy world of clowns, bagpipers, tattoo artists, and bathing beauties vaunting the "World of Tomorrow," and "Chemical Wonderland," all accompanied by brassy 1940s band music. Overwhelmed at first, Charles soon began to take it in stride. He received a kiss from world champion skater Barbara Ann Scott, sat on the lap of heavyweight boxing champion Joe Louis, and was told to climb the steps of the Bandshell to shake the hand of Prime Minister Mackenzie King. He also watched Elsie the Cow get milked, spoke to the French ambassador to Canada, laughed at comedian Stepin Fetchit, and met Quebecois woodsman Joe LaFlamme, who let Charles pet his tame moose, a moment later commemorated in Charles's paintings.

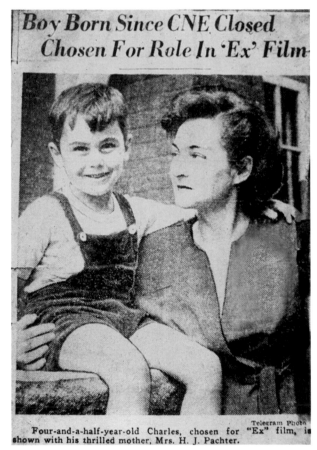

Charles remembers a scene in the film in which he is led by a police officer to the lost children's compound, locked up behind a high chicken-wire fence, while his parents and the film crew watch in the background.

The script required Charles to cry, so without warning Sara went over and swooshed a hunk of mud across his face. He burst into tears as the cameras rolled. A few

moments later, she rushed back and swept him up in her arms, to his delight. The resulting scene in the film, of a tired, cranky, lost child being reunited with his anxious parents, is a triumph of illusion. His two magical weeks ended when the Ex finished its run, and he was sent back to mundane real life.

The following spring, Charles was awakened one evening by his very excited mother, who dressed him in a bow tie, a sweater knit by his Aunt Ruth, and itchy wool

Charles and his mother in a publicity photo for *Johnny at the Fair*, *Toronto Telegram*, August 1947.

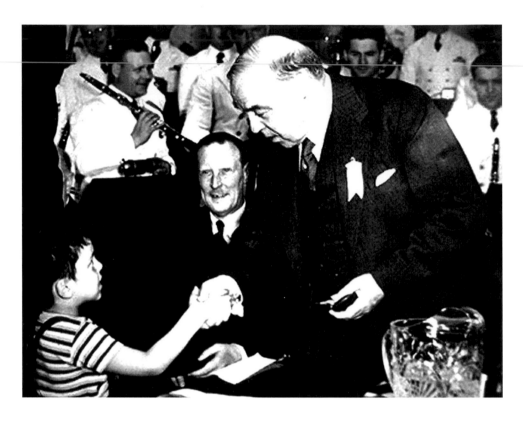

Charles shakes hands with Prime Minister Mackenzie King at the CNE, August 1947.

britches. He remembers vomiting from nerves before being whisked out into the night. When they arrived at the giant Shea's Theatre, where Toronto's City Hall now stands, he was interviewed in front of radio microphones shaped like fans, while Klieg lights blinded his eyes. Charles stood before a darkened audience for the "praymeere" (as he heard it pronounced) of a "Canada Carries On" presentation of *Johnny at the Fair*.

As Johnny, he was told to sign his name, which he had just learned to print, in people's autograph books, both at the theatre and later at B'nai Brith Lodge meetings. Lorne Greene, who narrated the film, suggested to him that he enrol in his acting school. Charles was five by then and had the illusory impression that "Canadian" meant glamorous. His parents were delighted to receive a cheque for $101.75 from the National Film Board for services rendered. This classic bit of Canadian kitsch played as a short in theatres all over North America for several years thereafter, and it is currently viewable on YouTube. This was Charles's first and only starring role, and one that left an indelible impression on the little boy.

Charles may have had a unique connection to the big screen, but he and his family had a relationship with the TV in their house that was typical of a 1950s family. Every Sunday night, the family gathered in front of their black and white TV to watch their favourite program, *Lassie*. The Pachters got a dog, too, which Charles named Leslie — that was what his grandmother called Lassie.

In one episode, a mean old lady named "Sara Dibbles" kidnapped Lassie, after which Charles decided to call his mom Dibbles. Finding she liked it, Sara started signing her letters with that name, and from that moment on she became Dibbles to friends and family.

At age 12, Charles sketched his dog Leslie, 1954.

Dibbles was indefatigable: she raised four kids, worked full-time as a travel agent and tour leader, and in her spare time was wardrobe mistress for shows with the Holy Blossom Temple Players, ironing the costumes backstage while Harry performed various roles in the plays. She was a firecracker, a cut-up, and a self-absorbed beauty. As travel agent for Fisher-Fremont Travel, she led tours to Israel a record-setting 166 times, in addition to thirty trips to China, Thailand, and Japan, and ten to Russia, every trip being "the best trip I ever took."

In her office she told an older woman who was struggling to negotiate a stairway, "If you can't get up these stairs, you're not coming to Israel." In Japan, a lady on the tour was still in mourning for her recently deceased husband, and didn't want to get off the bus to visit a shrine. "You shouldn't be on this tour. You're going back to Toronto," Dibbles told her, and she was promptly put on the next flight back.

When he was nine, Charles told her, "Mom, your problem is that you're … uh … domineering."

"I'M DOMINEERING?" she shouted. "I'll give you such a DOMINEERING!"

Despite everything, Charles and Dibbles were close. He inherited his mother's energy, and her sense of fun and adventure.

Charles's father, Harry, who he always referred to as "Har," tried his hand at many different businesses while Charles was growing up. After starting with a toy store where Charles obtained his first scooter, he then became a travelling salesman for a dress manufacturer, and later worked as a "customer's man" at numerous stock brokerage offices. He ended up in a little office on Eglinton Avenue selling Israel bonds.

Harry had many pals with whom he played poker and went to hockey and baseball games. As president of B'nai Brith Eastern Canadian Council, he attended many conventions in the Catskills in Upstate New York with Dibbles. Har had a wonderful gift for telling jokes and stories, and was in great demand as an after-dinner speaker. He was also a Mason. Charles can remember watching his father and a fellow Mason one day in an elevator. Spotting Mason pins on each other's lapels, Harry and the stranger immediately launched into an elaborate series of variations on a secret handshake that thoroughly mystified Charles.

Harry, who was an avid 8mm movie camera buff, recorded many highlights of his children's lives in jerky reels. During the 1950s and 1960s, scene after scene showed the family walking out the front door of their home, the women dressed for the High Holidays in outlandish outfits such as fur stoles with animal snouts, to

go to the Holy Blossom Temple across the street. Later, the family gathered, sharing screaming fits of laughter while reviewing the footage. There were rounds of birthday parties, candle-blowing, gooey cake with nickels wrapped in waxed paper; panning shots of little faces under paper hats peering out around the table, munching crustless chopped-egg sandwiches on brown bread; close-ups of Halloween loot being spread out on the living room floor, Dibbles nursing and bathing younger brother and sister, aunts and uncles jitterbugging on the front lawn, and four-year-olds playing in sand boxes, wrestling or smacking each other. Like father, like son, Charlie records a lot of what he does. On his computer he kept a diary of everything he did and everyone he met between May 1, 1989, and December 31, 1999. He also keeps copies of materials he has received, much of which can be found in the archives of the Thomas Fisher Rare Book Library at the University of Toronto.

The most dynamic personality among Charles's relatives was his Auntie Annie, his mother's petite, adventurous younger sister, who had gone down to Birmingham, Alabama, in the 1930s with a girlfriend, and had gotten married in a shotgun wedding to a sleazy character who was involved with drugs. Annie ended up being rescued by her grandmother and her older brother, who drove down to Alabama in an old Model T Ford, had the marriage annulled, and brought her home. Resembling Lana Turner, Annie was a classy dresser whose hair, whenever she visited the Pachters, always had a different colour. When she married boring Uncle Louie and gave him a daughter, the three of them moved to Las Vegas, where he became a croupier in a casino while she opened a Hudson automobile franchise.

She later divorced Louie, moved to New York, and managed the Park Royal Hotel on the Upper West Side near Central Park. As a teenager, Charles visited her several times and was taken to Broadway shows like *The Pajama Game, Li'l Abner, Oklahoma,* and *Carousel*. He later saw Ethel Merman in his favourite musical, *Gypsy*, at the O'Keefe Centre (now the Sony Centre) in Toronto in 1960. That show, based on the memoirs of Gypsy Rose Lee, left Charles with an enduring fascination with Ethel Merman, the brassy performer who reminded him of Dibbles, and whom he often imitates. He also knows all the songs by heart, which you will quickly discover if you ever visit him.

Annie also introduced him to the art galleries of Soho during the pop art era, took him to the Guggenheim and MOMA, and allowed him to see, for the first time, Matisse's *Dance* and Picasso's *Guernica*. This was probably the best time to be in New York, with

jazz clubs on every corner, the Yankees regularly winning the World Series, and abstract expressionists like de Kooning, Pollock, and Rothko showing in the art galleries.

One day Auntie Annie phoned him from the apartment in her New York hotel and said, "902 died. She had a gorgeous couch. I'm sending it to you." That's how he inherited his favourite piece of living room furniture, the one on which he habitually meditates.

The Pachter house at 84 Chudleigh Ave was near the "reeveen" (as kids called it), which they had to cross to get to John Ross Robertson Junior Public School, where Charles spent Grades 1 to 4. The ravine was magical. During forays through forbidden pastures, Charles found strangely shaped wild pumpkins growing there in the fall, and he believed he alone knew where they were. His love of the ravine may well have nurtured his adult attachment to a farm in Oro-Medonte, a waterfront studio on Lake Simcoe, and a large studio retreat in a quiet laneway in downtown Orillia.

Lake Simcoe has always played a major role in Charles's life. In the summers, when he was very young, his parents rented an old musty cottage on the south shore of the lake. The view west over the lake from the cottage was superb, allowing everyone to witness great sunsets and windswept waves.

Though it now seems like just another suburban area north of Toronto, in the 1950s the south shore of Lake Simcoe — Willow Beach, Filey Beach, Jackson's Point — was, to Charles anyway, far-away cottage country. The wind coming off the lake was powerful, and when it was wavy and stormy, it felt more like an ocean. Fishing in that lake with his dad combined adventure and responsibility. There was so much to keep them busy — attending to worms, leeches, and hooks; unknotting fishing line; putting down and pulling up the anchor; stringing perch and bass; bailing out the wooden boat and pull-starting the motor, a Johnson 10-horse with a sinister-looking cowl. They almost never came home without a good catch, which his dad cleaned expertly as everyone sat around making faces. His mother would coat the fish fillets with egg and flour, fry them in butter, and serve them with fresh summer radishes and tomatoes.

Several times a day, the kids slid from the cottage lawn down a bum-worn, grassy hill to a sandy beach that had the cleanest, clearest water imaginable. Jumping in and out of the lake, they dared each other to see who could swim to the big rock — only ten yards out and where the water was not quite over their heads. Once in a while Charles would discover a chartreuse-green leech the size of a kitchen knife, or a pinkish-beige crayfish with wiggling antennae, or a huge bullfrog looking like it was blowing bubbles, or a beautiful empty mother-of-pearl clamshell. Sometimes a

sinister-looking, half-decayed monster fish as long as his whole body washed up on shore, covered in frenzied flies and insects.

"A muskie, maybe a sturgeon," said his dad.

Down the road were more cottages of rich people, built in the middle of long, landscaped, strip lots divided by high cedar hedges. There was Myn and Morris Sugar's place, called Mynmor Gardens, with a rococo fountain you could see from the road, and there were the Applebaums with lots of Cadillacs parked in front. Almost every-one had a cottage with a name. When he asked what their cottage's name was, his father replied "Kosta Lotta," or "Machakada Sahapa," which was the first syllable of the name of everyone in the family (i.e., MAida, CHArles, KAren, DAvid, SAra, HArry, PAchter). Often Har drove the family into Jackson's Point where they walked around splitting and spitting out "shemeshkehs," or sunflower seeds. There were also pumpkin seeds and pistachio nuts, whose red-dyed shells stained everyone's lips.

Close by was the Tides Hotel, where some of their friends rented cabins and performed in hastily prepared summer skits. Dibbles would blacken her teeth with chocolate wrappers and put her hair up in pin curls to go out to one of these zany performances as a member of the Mafoofsky choir, made up of a group of friends who sang racy songs in pidgin English-Yiddish. For example: A boy in khaki ... a girl in khaki, underneath a khaki moo-o-oon. ("Kak kim oon" in Yiddish means "shit on that.")

In later years they moved to another cottage, farther west along the lake near the government dock at Willow Beach, a few doors from Sedore's general store, where kids hung out at the pinball machines while sucking on halves of strawberry, lime, or banana popsicles, the other halves stowed in shorts pockets. Charles didn't like this cottage as much as the first cottage. It had slanted floors, dank bedrooms, and green beaverboard walls and mice and bats. And you had to cross the road, dodging cars, to get to the lake, which had hairy green algae attached to the rocks, and a stony bottom. It lacked the wilderness feel of the first cottage. Charles found out the next summer that the first cottage had been towed out onto the lake during the previous winter, and was sunk through a hole in the ice.

The second cottage was closer to Roches Point, where the very rich people lived on huge lakeside estates that bore names like "Windarra" and "South Wind," with servants' cottages behind manicured stone walls.

One family, the Cowans, had their own movie theatre, to which Charles once was invited for a birthday party. The rich FOOFs (Fine Old Ontario Families) — the Matthews, Oslers, Laidlaws — were unknown to the young parvenus. It wasn't until

some fifty years later that Charles was invited to a cocktail party at one of these summer palaces, where he was greeted by a neighbour who introduced him as "the artist who painted the queen on a moose." It was then that he remembered wandering as a kid along the cedar-hedged roadway outside the forbidding gates, slapping mosquitoes, and wondering who on earth was lucky enough to live there.

By 1950 the house on Chudleigh Avenue had become too small for the family of six. Wanting Maida and Charles to be closer to the Holy Blossom Temple religious school they were attending, Dibbles and Har bought a larger, mock-Tudor brick and stucco house at 83 Ava Road, across from the "Holy B," as it was called. The neighbouring kids on Peveril Hill and Ava Road were quite different from the proper little Anglicans he had known on Chudleigh Avenue. These new kids were mostly Jewish, with names like Hushy (Harold), Moishy (Marvin), Gutman (Goody), and Gedalya (Gary), a far cry from the Jeannies, Johnnies, and Betties he'd known north of Eglinton.

The new house had diamond-paned leaded glass windows, a garage door that opened and closed automatically, and an unused attic that Charles transformed into a working studio where he spent the next two years painting. One day his sister Karen begged him to let her see the attic. He finally agreed and helped her up a ladder and through the trap door in the ceiling of his bedroom closet. Once she was up in the attic, he took the ladder away. She screamed, but eventually he brought the ladder back and let her down.

Alone in the attic he drew trees, still lifes, imaginary Middle Eastern cityscapes, and sketches of Centre Island.

If fine art was not a major focus in Charles's family home, his parents still felt that the children should be exposed to the arts. His sisters had taken ballet and piano lessons, but his younger brother showed no particular interest in things cultural. Whatever their own interests, his siblings all felt that Charles got special treatment. At dinner, whenever Dibbles put a larger portion in front of him, they would point accusing fingers at the food and scream in unison, "FAVOURITE!" Everyone would then dissolve in laughter as his mother tried to defend herself by adding extra morsels to their skimpier allotments. This was a hilarious ritual, but underneath it there was a considerable amount of jealousy.

"The trouble with you," Dibbles told Charles, "is that you think too much and you're too smart for your own good." When he told her he wanted to be an artist, she replied, "You want to paint? Paint the bridge chairs!"

Four Pachter children —
Maida (rear), Karen, David,
and Charles.

His widowed immigrant grandmother, Eva, who called him "Charl" because she thought Charles was plural, told him, "Go foist to university. After dat you'll know if you still want to be an artist, but a doctor is better." When he received an honorary doctorate from Brock University in 1996, he was able to tell an interviewer, "Now my mother can call me doctor."[1]

Charles was also discovering that he enjoyed playing with words. The Pachters had a spotted black-and-white cat named Viveca, who had a mess of kittens, prompting twelve-year-old Charles to phone in an ad to the birth column of the *Toronto Star*. It read: "Katz, Viveca, is thrilled to announce the birth of quintuplets, at home, by natural childbirth. Mother and babies doing well. Father's whereabouts unknown." After the ad appeared, the papers called immediately, wanting to do interviews and take pictures, but Charles, the budding satirist, told them, "She's resting after her ordeal and prefers to remain anonymous."

Charles completed Grades 5 to 8 at John R. Wilcox Public School, and came in first in a public speaking contest. His Grade 5 teacher, Miss Dickson, told his parents that his work was satisfactory but "less talking would help."

In the summer of 1953, his parents sent him to Camp Tamarack, a Jewish Boy Scout camp. After three weeks he wrote his parents:

> Dear mom and dad,
> I have just come back from swimming and I got a few bloodsuckers on me and now I have a few sores from them…. Last night I got sick in the stomach and was up all night…. I went to the bathroom and found out that I had diarea [sic]. Write soon.
> Charles[2]

Along with the troubles that Charles outlined in his letter to his parents, he was also paddled by the old Scout Chief — a sort of initiation rite supposed by one and all to be an honour. Charles, however, thought it was weird.

He was told to climb the steep wooden stairs to the cabin of this old man who was held in awe by the rest of the camp. The Scout Chief promptly took a Ping-Pong paddle and whacked Charles on his bare butt a few times, taking an unnatural delight in his task, grunting as Charles grimaced.

Years later, at Camp Northland, Charles watched with nervous curiosity another example of a strange camp ceremony. In that incident he was witness to what was known as a "circle jerk" — six or eight boys sat around a campfire, displaying the newly discovered capabilities of their anatomical hoses to curious onlookers.

This experience caused Charles some unease. As is typical for adolescents, he experienced some anxiety associated with his emerging sexuality. Although by the time he reached puberty Charles had fooled around a little with girls, as he moved into his teens he found that he was less interested in them. In fact, he found that he wasn't interested in many of the activities the rest of the boys of his age were engaging in.

As Charles grew, Dibbles often came to his bedroom door, concerned that her son wasn't outside playing with the other kids or doing something useful like watering the garden. Charles came to realize he was not like the other kids.

"What will we do with him?" he heard his mom saying to his dad at the kitchen table from his vantage point on the stairs.

"Maybe we should give him some art lessons," replied his father.

From that point on, while other little boys were outside in the street playing hockey or discovering girls, Charles was taking art lessons, music lessons, and drama lessons.

CHAPTER 2

Lessons Learned

Of the various teachers in Charles's life, including high-school teachers Miss Hudgins and Miss Curran, and Ron Satok, an artist his parents retained to instruct him, the most influential and charismatic of his teachers was Rachel Cavalho, the forty-eight-year-old piano teacher who entered his life when he was eight. A tiny woman, she was always impeccably dressed, with a lace hanky wedged in her blouse sleeve and just the right understated necklace. She always wore her face made up like a little China doll, with false eyebrows painted black, little rounds of cheek rouge, and daubs of green over her eyes.

Temperamental and stubborn, she fancied herself the inspired mentor whose job it was to develop his skills, his higher thoughts, and his aspirations, and in so doing to transform him into an educated young man of breeding.

Once she took hold of Charles, Rachel wouldn't let go. To describe their relationship as a teacher-student one is too simple; he was her full-time project. She was testy, hypersensitive, unhappy, and judgmental, but thoroughly dedicated to her work. She lived in a world of novels, minuets, and sonatinas, nostalgic for a civility and grace she had left behind in London and was unable to find in Canada. Above all, she was dedicated to keeping the banal outside world at a distance. Discipline was her religion; emotion to her was base and self-indulgent.

She compelled Charles to help her move to an apartment over a hardware store on Eglinton Avenue at Warren Road, where he studied with her from age ten to twenty. The main room was dominated by her pride and joy and *raison d'être*, a Bechstein concert grand piano and some carefully chosen exquisite *objets d'art*: a nineteenth-century painted-wood sculpture of a serene Japanese woman, which she always referred to as

Charles's music teacher,
Rachel Cavalho, 1963.

"my goddess," a Chinese carved chair, some silk tapestries, and a nineteenth-century ink drawing by Rousseau.

It was Rachel who first took Charles to the Art Gallery of Ontario to show him *Portrait of a Seated Woman with a Handkerchief*, ascribed to the circle of Rembrandt. As he took in the textures of the starched white neckpiece, the flesh tones, the limpid eyes, the saddened smile, Rachel stood behind him, a ten-year-old kid, her hands on his shoulders, saying prophetically, "This is beauty. Therefore, you must always, always love it." Charles also viewed paintings by Riopelle, McEwen, Bush, Wieland, Coughtry, and his hero, the satirist Honoré Daumier.

When Charles was eleven, Rachel introduced him to Dickens's *David Copperfield*, showed him the fantasy drawings of Paul Klee, made him read Janson's *The Story of Painting for Young People*, and had him report back on his favourite artists.

Musically, she gave him pieces to play by Bach, Schumann, and Beethoven. She taught according to her own methods, eschewing the Conservatory books and grading system. She got him to perform in student concerts at the Unitarian Church at Avenue Road and St. Clair and in the home of the Nunes-Vaz family, whose children were also her students. Charles was usually unprepared and more or less faked it, but he could get a good response to a hammed-up rendition of Debussy's *Golliwog's Cakewalk*. This infuriated her because, she told him, "Even without any proper technique you managed to carry it off!"

Her favourite description of Canadians was "barbarians." "Canadians worship mediocrity," she uttered disdainfully. She once announced casually during a piano lesson, "Darling, it's not your fault you're from peasant stock. You have the capacity to become a gentleman."

Charles came home to a supper of spaghetti and meatballs and promptly repeated this. His mother replied: "Peasant stock? I'll give her such a peasant stock! Who the hell does she think she is!"

Rachel continued to coddle him, putting up with his youthful gaucheries and teaching him proper manners. She also pointed out his strengths, calling him "Papa Charles," telling him he was a born leader, and insisting that what he needed in life was a maid, not a mate.

When Charles was fifteen she invited him to come early one day to a piano lesson after school. She sat him down at an elegantly set table on which she placed an amber

Limoges plate. It contained a small piece of runny Brie cheese and some biscuits, and was accompanied by a glass of medium-dry sherry. As he surreptitiously doffed his heavy rubber boots beneath the table, "fresh" from a high-school gym class, she squiggled up her nose and asked with some dismay, "What is that peculiar smell?"

"Must be the Brie," he ventured meekly, rubbing his pungent socks together.

Next, she leaned over, eyeing him directly, and asked, "Charles, have you had an affair?"

He replied nonchalantly, "Well, yes, my bar mitzvah was a sit-down affair for two hundred."

"No, no," she corrected him. "Darling, if you're going to be an artist you must go to *Frawnce* and learn the French language."

Four years later he went to France.

Another teacher his parents found for him was Ronald Satok, an artist who ran a little studio over a store on Eglinton, west of Bathurst. As Charles sketched portraits of a black model in a gypsy costume, Ron hovered behind his shoulder, redrawing a line here, a shadow there. He set up still lifes of a teapot, a bowl, a few candles. Charles came in one day with a still life he had done at home, teeming with objects: salt and pepper shakers, vases, drapery, a black-and-white checkerboard, candlesticks, fruit, a salad bowl, a tray.

Ron looked at it, shook his head, picked up a brush, and asked, "Do you mind?" then started to paint over most of the objects, leaving one piece of fruit, a bowl, some drapery. At first Charles was appalled. Then he realized what Ron was doing as he pared the image down to essentials, visually editing with a rhythmic grace, humming softly to himself as he painted over the non-essentials. That lesson was never forgotten. Charles's 1979 painting *Six Figures in a Landscape* is the first and best example of his focusing on the figures and eliminating the background. Art historian Bogomila Welsh-Ovcharov later compared it to the work of French painter Émile Bernard.

At Vaughan Road Collegiate, Charles's Grade 11 French teacher, Miss Curran, told him, "you have a great ear for the French language. You should go to Quebec on a *visite interpro-vinciale*." Two years later Charles spent the summer of 1959 in

Oil on canvas, 1956.

Montreal living with a devout Catholic family from Belgium. The father worked in the Cadbury chocolate factory, the mother minded their apartment, and their son Hubert guided him through a maze of linguistic jargon. It was a joyful learning adventure. They drove to Quebec City, clip-clopped around the old town in a calèche, visited the grand historic museums, and saw the Plains of Abraham and the Chutes de Montmorency, which he had only previously seen in Cornelius Krieghoff reproductions. The experience was mystical and funky, and it introduced him to a new French-Canadian reality.

His art teacher at Vaughan Road Collegiate, Miss Hudgins, ran her class like an army sergeant. Charles recalls one class in particular. "Sit down please," she trilled as their class began. Then suddenly she barked, "I said, SIT DOWN!" She placed a daffodil in a vase in front of the class, and barked, "Start WORK!" Twenty minutes later she yelled out, "Pencils ... DOWN! Stop ... WORK!" Of Charles she demanded: "Hold up your picture, dear!"

He did. Charles had painted the daffodil blue.

Vaughan Road Collegiate Art Club, Miss Hudgins, middle row centre, Charles far right, 1957.

"What would you give that out of ten?"

"Nine?" he responded.

"No, three," she pronounced flatly.

"Three?" he protested in dismay.

"Three detentions!" She then admonished him. "Daffodils are not blue! "She gave him a D minus.

By the time he made it to Grade 13, Miss Hudgins had become the school's guidance teacher. She told Charles, "You're going to be a successful artist because not only can you draw and paint, but also you have a big mouth." She phoned him forty-five years later when she learned that he had received the Order of Canada. "You know who this is, don't you?" she gushed. "I always knew you had it in you, dear."

CHAPTER 3

Blossoming Out

When Charles's family moved from Chudleigh Avenue to Ava Road, they joined the Holy Blossom Temple community. Known colloquially as the Holy B, the Holy Blossom Temple was founded in 1856 and is the oldest Jewish congregation in Toronto. For the first twenty years of the temple's existence, services, conducted in the traditional Orthodox manner, were held in a rented room over Coombe's Drugstore on the southeast corner of Yonge and Richmond Streets. By 1899 it had 119 families, had introduced music, and had begun to allow men and women to sit together. In 1920 their spiritual leader, Rabbi Brickner, sought and obtained affiliation with the Reform movement. On May 20, 1938, a new building opened on its present site on Bathurst Street. Rabbi Abraham Feinberg served as spiritual leader for many years, followed by W. Gunther Plaut, who died in February 2012 at the age of ninety-nine. The Holy B has always been known for its active role in issues of social justice, from civil rights in America to anti-apartheid in South Africa to programs for feeding the hungry and homeless in Toronto.

Religious school seemed as important to Charles as public school since his family lived across the street from the temple. The building, grounds, sanctuary, tower, and school had become Charles's domain. He knew everyone and they knew him: the caretaker, Mr. Tubbs, and the secretaries: the professional Jewish single, Miss Ethel Press, who ran the religious school office, and the rabbi's secretary, Scottish Presbyterian, carrot-topped, Miss Margaret Davidson. One of his teachers, Rosalie Shadlyn, discovering his talent for calligraphy, cajoled him into making eighty graduation certificates for the Holy Blossom confirmation class of 1958.

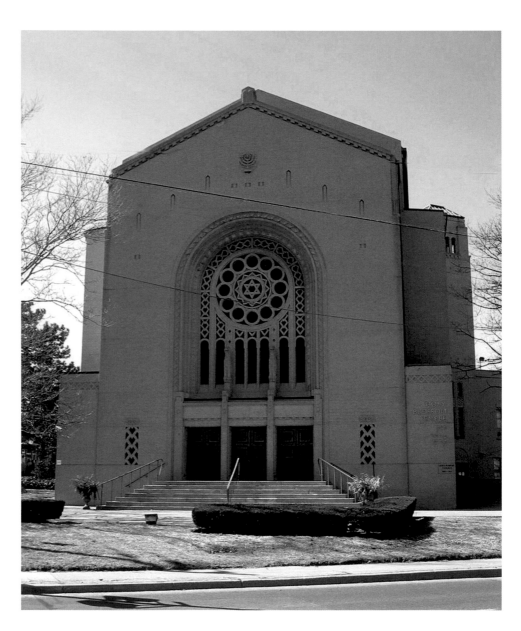

Holy Blossom Temple,
Bathurst Street, Toronto.

Chief among the characters at the Holy B was Heinz Warschauer. The intense, quirky, moody principal of the religious school, Warschauer was the single greatest influence on all the students there. Unavoidable and intimidating, he often showered verbal abuse on young students and even inhabited their dreams. A confirmed bachelor, prone to demonic outbursts of anger and contempt for those closest to him, he was a transplanted German-Jewish intellectual who had escaped the Holocaust, arriving in Canada

via Shanghai, only to end up at Bathurst and Eglinton running a religious school and bitching at everyone with whom he came in contact.

He was a born teacher who could sniff out the potential in his students and manipulate them accordingly. If you were smart, you were recognized by him as such with much fuss and expected to do something responsible with your abilities, but if you were unmotivated, he'd glare at you and put you down. Charles clearly met with his satisfaction. He hired him to run the school's art program. "This is to confirm your appointment," wrote Heinz, "as Director of Religious School Arts and Crafts at a salary of $650 per annum."[1]

Twenty years later, upon learning of Heinz's s retirement, Charles wrote his former teacher, "It is a privilege to write to congratulate you on your imminent retirement … you encouraged me to build a portable ark … which I am told is still in use, a small but lasting tribute to you."[2]

Some of the students Charles remembers from that time in his life are Virginia (Margolius) Solomon, Michael Levine, Clayton Ruby, Edward Borins, Arthur Pape, David Mirvish, Barry Zaid, Melanie Conn, and, especially, Rick Salutin.

"When we met at age nine in Hebrew school," Charles remembers, "Rick was called Yisroel and I was known as Shlomo. He was serious and I was funny, but we both seemed to excel at tormenting the Hebrew teachers." Rick soon became the first close friend Charles made at the temple, one with whom he has maintained an on-going relationship through adulthood.

Together they edited the student magazine, the *Tempelite*, and belonged to a tight-knit little group called the HBYC, the Holy Blossom Youth Council. Sitting around with other budding teenaged intellectuals, known as "Heinz's hothouse flowers," they discussed Buber, racism in Alabama, the Middle East and the Jewish problem, but not much about Canada. They often biked over to Centre Island and sat under a willow tree while Rick talked about writing and Charles sketched.

"I thought Rick's writing was very sophisticated for someone his age," Charles recalls, "and I especially liked the clipped, terse style of his short stories."

Rick took religion seriously and studied constantly, becoming a thinker, a philosopher and a Talmudic scholar. But the two of them also had another side to them, sneaking into the tower at the temple and leaving notes saying, "The Temple Phantom was here." They went on temple student bus trips to the United States, competing over who knew Broadway musicals best, laughing all the way.

Watercolour and ink sketch of trees, Centre Island, 1962.

At Camp White Pine, where they were later both on staff, they saw each other more often. Charles rarely went on canoe trips, tied knots, or built campfires, his sole interest being art. He directed the camp musicals that Rick wrote, one of which was based on the James Bond film they had just seen in the town of Minden.

Rick met Melanie Conn at camp, became her boyfriend and married her four years later on one of the camp's days off. Many from camp drove down to Toronto to witness their wedding at the Holy Blossom chapel. Without anyone's knowledge, Charles had previously driven to the city with his tape recorder and interviewed as many of Rick's relatives as he could find. On his return to camp, while everyone gathered to watch, he surprised Rick with his own version of a very popular TV program at the time. "Rick Salutin," he shouted, "This is your life!" Then he brought out a number of staff members dressed like Rick's relatives.

Rick later wrote him, "Your effort on behalf of that unforgettable *This Is Your (My) Life*, was the finest wedding gift we had...."[3] "This summer was the first time in years

we have really spent much time together. It may have not been that big but I think we talked more than we ever have and I suppose I didn't realize how much I miss it."[4]

Whenever Rick went to Toronto with Melanie, he visited Charles and was shown the artwork he and Margaret Atwood were doing together. Rick loved Charles's art and often defended him later in print in the *Globe and Mail*. Like all friends, however, they had their share of disputes. At one period in his life Rick had to get an unlisted phone number because of death threats from irate readers of his column. When Charles naively gave out his phone number, Rick told him he was being malicious, that he should have phoned him first. Another time they had a falling out over a character in one of Rick's novels. But they always reconciled and resumed the friendship that continues to this day.

Rick Salutin at Charles's show "Streetcars" at Isaacs Gallery, April 1972.

CHAPTER 4

Camp White Pine

It was at Camp White Pine that Charles Pachter met Margaret Atwood, who became, and continues to be, his close friend.

Charles at sixteen was the assistant to Beck Breland, the head of arts and crafts, and was known as Charlie A&C. In his first year at Camp White Pine, Charlie assisted Breland by helping teach the children how to make ceramics. In his second year he graduated to the arts and crafts cabin, where he taught collages, linotypes, printmaking, and silkscreening to groups of fifteen kids at a time.

One day, when a kid threw up on the kraft paper, Charlie exclaimed, "Oh, a collage!" He proceeded to smear it around and was able to turn an accident into an abstract painting while saving the child a bit of embarrassment.

One of Charlie's prints, a silkscreen of a forest used as background in one of the images in the Susanna Moodie book, is now in the private collection of Joe Kronick, the camp's owner. Another, *Birds in Flight,* ended up being purchased by the parents of Margaret Atwood.

Atwood was nineteen, and at camp they called her Peggy Nature. Like a young Jane Goodall in shorts, T-shirt, and rubber boots, "Peggy Nature" worked out of a shack called the Nature Hut, where she stored jars full of various creatures found around the camp — turtles, worms, caterpillars, and snakes. One day, while showing them to a group of young campers, she spotted Charles and motioned him to come over. "I want you to stroke this toad for me to prove to the kids you won't get warts." He did what she asked and didn't get warts.

From that day on they became buddies and confidants. He was already roguish at that age, playing practical jokes on other staff and asking Atwood impertinent personal questions. They would sit by the lake slapping mosquitoes and sharing anecdotes. She cracked up over his politically incorrect jokes while he loved her intellect and her brilliant way with words.

When summer ended, she and Charles remained pals when they got back to Toronto, visiting each other's homes often. Hers was a prim family, living in a modest bungalow on a quiet street in Leaside, where they offered him milk and home-baked cookies whenever he visited. When Margaret came to his mock-Tudor house in Cedarvale, she joined in the pranks and sampled *kishka* (a Jewish delicacy consisting of a cow's intestine stuffed with carrots, flour, and onions).

When his parents gave them their tickets to the Canadian National Exhibition, he and Atwood went, pretending they were Mr. and Mrs. Pachter. He insisted that they ride the big roller coaster, which Atwood hated, and he reluctantly ended up having to go with her on the smaller ride, the one for sissies. "Within two minutes," Atwood related, "he was on his knees holding my legs, crying, 'Please make it stop.'"

Charles and Margaret at a Camp White Pine reunion, 1980.

Wherever they were, Margaret and Charles kept in touch with each other by mail for years. They also found ways to work together, combining their great talents. Charles would later illustrate six of Atwood's poetry collections. Two of the best known, *The Circle Game* and *The Journals of Susanna Moodie*, were published in stunning limited editions on handmade paper.

Atwood also used Charles, or a version of him, as a source of inspiration. A fictional character with some Charles-inspired characteristics makes an appearance in her comic novel *Lady Oracle*. Its heroine, a romance novelist, imagines alternative lives, one of which involves Chuck Brewer, a part-time commercial artist who calls himself "The

Charles and Margaret, 1966.

Royal Porcupine." The guy has a beard, dresses in a top hat, cape, and cane, and looks like someone from a previous era. The Brewer character lives in a downtown warehouse converted to artists' studios, where the protagonist, a writer named Joan Foster, carries on an affair with him. Together they frequent junk shops, Sally Ann stores and Crippled Civilians' outlets looking for ugly statues, cheap hats, and second-hand vests and shoes. She takes him on book-promoting tours and to literary gatherings, always pretending to meet him for the first time. Later she changes her mind about him when he shaves his beard, cuts his hair, wears T-shirts and jeans, and seeks a mundane existence with a wife, children, and a job. It was a portrayal that alluded to many of the things they shared and one that touched Charles profoundly.

As the years went by, though Margaret and Charles were often far apart, they always stayed in touch.

CHAPTER 5

University of Toronto

In 1960 Charles, now called Charlie by his friends, enrolled in Art and Archeology at the University of Toronto, taking lectures in a dingy old Victorian house with creaky stairs, on the site where the Planetarium now stands, just south of the Royal Ontario Museum. Most of his two-dozen classmates were lanky female debutantes from Trinity College. "I used to tease them," he remembers, "calling them SWITS — society wives in training."

A routine soon emerged, with Charlie escorting two or three golden *shiksas* (non-Jewish girls) to Spadina Avenue for an introduction to Jewish cuisine. At United Dairy Restaurant they tried cheese blintzes, and at Switzer's Deli they discovered corned beef on rye which, to Charlie's dismay, they often ordered with a glass of milk.

Among the guys in "Art'n'Arch" there were a few eccentric scholars and book-worms. Charlie had already decided that he was going to be an artist and wondered if he'd chosen the right place to study, but as he explained in his Honorary Doctorate speech to the U of T graduates in 2010, "having been exposed to history, languages, and philosophy at U of T, I now realize that nothing could have better prepared me for becoming a painter than to have studied Plato, Chaucer, and Baudelaire as well as Tintoretto, Edward Munch, and Emily Carr."

In the 1960s the faculty were a somewhat stodgy bunch of professors who seemed mostly old and dotty to a seventeen-year-old student. Of all his teachers at U of T, the ones Charles remembers best are Stephen Vickers, the old, curmudgeonly art history prof who placed Charles in a darkened room and required him to identify hundreds of Renaissance artworks in order to get credit for the year he spent in Paris, and sculptor

Reminiscence of a Euclid Avenue House, 1964, oil on masonite.

Ted Bieler, who was his studio professor. It was in Bieler's studio course that Charles painted *Reminiscence of a Euclid Avenue House*, 1964. The assignment was to create an image from memory rather than from a source photo. The painting was based on Charles's memory of his bubby's Victorian house. Echoing Chagall in colour and form, it may have brought out semi-conscious memories passed down from his grandparents. Now, more than fifty years later, it has turned out to be one of his favourite paintings. It still hangs on the wall of his studio loft.

Another teacher who had a strong influence on Charles was Fred Hagan, the hard-driving, opinionated, hypercritical printmaking instructor at OCAD who taught Charles silkscreening. While Charles was there, in a defining moment, Atwood sent him her own silkscreen equipment, frames, and squeegees so that he could make serigraphs by himself at his first studio, on the top floor of a house in Mirvish Village on Markham Street. Atwood's parents paid him twenty-five dollars for *Birds in Flight*, the first silkscreen he ever made.

Charlie's graduate year at U of T was notable for two things: his painting *Reminiscence of a Euclid Avenue House* and a catchphrase. The phrase was one he invented for use in essays on anything from Greek sculpture to abstract expressionism. He wrote: "The eye is drawn upward by the monumentality and the tonality, and the orchestration of

Birds in Flight, serigraph, 1961.

colour and the positive and negative balance," which earned him a "B-plus very readable" every time he used it. Eventually his Trinity College classmates adopted it as their mantra as well, and also got "B-plus very readable" — much to their delight.

Charles's favourite hangout at the University of Toronto was in the stacks at the Sigmund Samuel Library, those underground corridors with endless shelves of ancient leatherbound volumes produced by obscure authors of centuries past. The first book to make an enduring impact on him was *The Shape of Content*, by Ben Shahn, the American social realist painter who wrote passionately about the key role artists could and should play in the university community. From Shahn he learned that art is not only about pushing paint around, but also about ideas and how best to communicate them. Shahn wrote that artists should work at various jobs before attending university and that they should use all their senses, but, above all, they should read everything they can, listen to others, draw and paint as often as possible, learn other languages, especially French, and form their own opinions.

Also significant was an illustrated catalogue titled *The Artist and the Book*, published by Harvard College Library in 1960, containing sample pages from the best nineteenth- and twentieth-century handmade books, in the tradition of the French *Livres d'Artistes*

Graduation, University of Toronto, 1964.

created by Matisse and Picasso. Years later, Charles would be turning out his own majestic handmade books, illustrating the poems of Margaret Atwood, Alden Nowlan, and John Newlove.

During his second year of university, Charles silkscreened posters for UC Follies, sang in the chorus with a young Barbara Amiel, and sold his first painting, *Meshach, Shadrach and Abednego*. It was a large, almost sculptural picture of three grotesque figures taken from the Bible, painted in lurid colours of red, yellow, and blue, and purchased by Paula Citron, a friend of his sister, Maida, and later a well-known theatre and dance critic. He showed some of his work at his home on Ava Road to raise money for the 1962–63 school year that he planned to spend in Paris. His mother's bridge-club friends, Gertie Wise, Lil Cole, Ida Fienberg, and Sally Libman, purchased many of these works, including an abstract painting he called *Howe's Bayou* (How's By You?).

Although Charles appreciated the support of these women, he also couldn't resist poking fun at them. From the time Charles was seven years of age, whenever his mother's loud-mouthed, perfumed bridge-club friends met for their card games, they would

intimidate him, pinch his cheeks, and holler things like, "You haven't kissed me yet!" or "If you don't hug me, I'm going to murder you!" then aggressively kiss him with saliva-covered lips.

When he turned seventeen and was still living at home, he finally got his chance for revenge. One night Charles sneaked into the living room and glued handfuls of steel wool to the armpits of two of his mother's ballerina lamps. Later that night, during their regular game, one of the bridge ladies spotted the lamps and yelled, "Sara, what the hell happened to your lamps?"

A few years later, the bridge club ladies also became the unwitting models for Pachter's first attempt at a satirical painting, *The Hiya Dolls*, completed at the Cranbrook Academy of Art. It depicted four excessively made-up women lined up in a row, each topped with sprayed beehive hairdos. The name of the picture came from the salutation they used every time they greeted each other.

Above: Charles repaints his mother's lamps for Gracie's restaurant, 1980.

Left: *The Hiya Dolls*, acrylic on canvas, 1965.

———————

One day in 1964, while still a student at U of T, Charlie paid a visit to the Pollock Gallery, located three doors from the studio he rented in a house on Markham Street, to show its owner his early silkscreens. Jack Pollock was so taken with them that he offered Charlie a showing in February 1964 at his Markham Street gallery. This was Charles's first solo exhibition in a commercial space.

In the *Toronto Star*, February 3, 1964, art critic Elizabeth Kilbourn called nineteen-year-old Pachter, "an enterprising young newcomer." It was a promising debut for one so young.

However, Jack Pollock, in his own memoir, wrote a scathing comment about Charles, suggesting that while he may have had great talent, he was too slick and clever, that business and hustling seemed more important to him than art, and that his interest in painting a moose as a subject for Canadian art was embarrassing.

This was the type of knee-jerk reaction Charles was to encounter often in his later career from various art critics in the mainstream press, but it served to endear him even more to his growing public fan base.

CHAPTER 6

A Different Journey

While Charles enjoyed taking the girls in his art history classes to lunch, he didn't date any of them, much to the dismay of one attractive redhead, who did everything in her power to attract his interest. Charles's romantic life at university was not typical, but he was not alone. Of the boys in his class, several were, according to Charles, "gays-in-training."

Charles had not yet accepted his sexual orientation, but from the tender age of ten he came to realize that he wasn't like most other boys. Whenever his school chums showed him *Sun and Health* nudist magazines containing pictures of busty women in lacy bras, they failed to have the expected effect on him. No matter how he tried to become aroused by erotic images of women, it didn't happen. He found women in garter belts and high heels more comic than erotic. When Charles stayed on occasion as a teenager at the Greenwich Village apartment of his parents' friend, Philip Katz, he remembers how aroused he was by pictures of attractive young men in the shop windows, but he remained strongly in denial.

It wasn't until Charles was nineteen that he got up the courage to sit at the kitchen table and tell his parents, "I don't know how to deal with these feelings I have. I'm attracted more to men than women." His parents were perplexed and didn't know how to deal with it either. Charles wrote about it in anguished letters to Atwood. She knew very well that he was struggling with his sexuality and that he thought he was seriously ill.

Charles decided that he needed to get away. The University of Toronto Art History program offered an option called "Third Year Abroad," where a student could apply to take a year to study in Europe. Following Rachel Cavalho's advice, he left U of T after second year and enrolled in a school for foreign French teachers at the Sorbonne in Paris.

At the Faculté des Lettres at the Sorbonne, he joined a class of thirty students from around the world who were there to polish their French. Quoting the works of Molière and Racine, the teachers, some of them retired actors from the Comédie-Française, extolled the beauty of the French language. Charlie exulted in it. While Canada was mostly about the beauty of the natural world, Paris showed Charlie the beauty of man-made monuments, from the Louvre to the cathedral of Notre Dame, Sainte-Chapelle to the Place des Vosges. While studying at the École Supérieure de Préparation et de Perfectionnement des Professeurs de Français à L'Étranger (a very long name for a very small department), Charles also worked briefly as a café waiter near Rouen, drew at night at the Académie de la Grande Chaumière, and discovered the streetscapes of Montparnasse.

As he wrote to his friend, Ed Roman, he felt very alone there.

Charles waiting tables at a friend's café in Rouen, 1962.

Paris isn't the Gay Paree the myth would have everyone believe. It's not gay if you don't have someone to share your joy and exultation with. I don't know what this city has done to me but I keep hoping for some angel to walk with me arm in arm down the grand boulevards, through the parks and by the river. It actually makes you want to be in love, a sort of miserable ecstasy. When I see all the couples lost in each other, oblivious to the common world, I suddenly realize what I'm missing. I never felt like this before and frankly it frightens me.[1]

View from window, Neuilly-sur-Seine, woodcut, 1963.

A few months later, he encountered his "angel" on a student tour from Paris to Rome. M. was a French Art History major, whom Charles described in his diary as "brusque in manner, with narrow eyes and a pout emphasized by thin lips. She wasn't beautiful but had a sexy body, thin waist, large hips, ample bosom, good skin and long, jet-black hair which she wore in a twist. She looked Italian." She observed him on the train doing his shtick, making jokes, and "entertaining the troops," and seemed to take an interest in him. How Charles knew this he wasn't sure, but he knew. It was the way she looked at him or how she reacted to his shenanigans.

At some point, having spent the day wandering through ruins, a group of them ended up in a nightclub off the Via Margutta in Rome, and he remembers drinking a lot. The first time he danced with her, he knew she wanted more. It was a new sensation for him. They kissed at the end of the dance. Charlie wasn't exactly sure what would be next. She remained close by for the rest of the trip and accompanied him on the train back to Paris. He was polite, detached. When they arrived at the Gare de Lyon, she gave him her phone number and said she hoped they would stay in touch. They spoke to each other

Vers le Soleil, watercolour of Champs-Élysées, 1962.

only in French. He suggested they go to see a Picasso exhibition at the Grand Palais on the following Monday. They agreed to meet at a specified time in front of the museum. His thoughts raced as the days passed.

Charlie arrived at the museum, where she stood waiting. Then they both realized it was closed on Monday. Embarrassed at first, he then asked her if she would like to see his apartment. "*Volontiers!*" she replied, and together they walked up the Champs-Élysées to Neuilly Metro Sablons, picked up some meat, cheese, salad, wine, and a baguette, and went up to his little *garçonnière* (bachelor apartment) in a handsome twenties apartment block off the Bois de Boulogne.

The one-room apartment had little more than a bed, a chest, a sink, and a table. They sat down on the bed, and that was that. They rolled around kissing passionately with their clothes on, stopping eventually to catch their breath. After more groping, she suggested she make dinner and created a sublime little meal from the groceries they had bought. Warm and aroused, they ate, chatted, drank, and looked at each other the way expectant twenty-year-old lovers do. The meal over, he thanked her formally, offering to walk her to the subway, saying he hoped to see her again. She looked at him, astonished, and asked, "*Est-ce que tu vas me jeter dans la rue? Tu ne veux pas que je reste avec toi?*" ("Are you going to toss me out into the street? You don't want me to stay with you?")

It's now or never, he thought. *Moi, awkward Canadian virgin, here in Paris, with a real live sexy French girl who wants me to make love to her.* He offered her his pajama top. She changed into it, he turned out the lights, and they got into bed.

Charles remembers the ardent kissing and fondling, the exhortations, his excitement, the fumbling, groping, her expert fingers guiding him in, his embarrassment at her having to do this, his feeling of frustration, and then the exquisite sensation he suddenly felt being inside a woman for the first time. They made love twice more during the night.

Awkward the first time, he was more daring the second time. The third time he was a seasoned veteran. By morning he felt like a born-again stud. *Ah, l'amour à vingt ans!* She was two years older than he and certainly more aggressive sexually.

As spring wore on, Charles and M. spent more time together. She helped him with his preparations for his French exams, and he decided to write the literary level exams at the École Supérieure. He suggested they vacation together at the end of school year, she suggested Corsica, and off they went by train to Nice, where they embarked on a big white ship to the town of Calvi in Corsica.

For two weeks they did nothing but swim, eat, make love, sleep, and wander the beaches and coastal towns. They had their own little tent by the sea that the French called *les tourtereaux* (the lovebirds), in one of those prototypes for Club Med called Club Olympique. They ate at a common outdoor dining area with others but were left to their own resources for the rest of the day. Although he welcomed the constant lovemaking, he began to find it becoming routine toward the end.

Since Charles had agreed to return to Camp White Pine as an art and drama instructor, he knew that his time with M. was coming to an end, so he made the most of it. He has never forgotten those golden days and starry nights in their tent by the sea. Departing for Canada, he vowed to write, calmed her fears, and ended up a week later back at Camp White Pine for the summer.

When camp ended, he resumed piano lessons with Rachel Cavalho. During one lesson, after he was telling her about M., Rachel squawked, "That girl is a strumpet. You need a woman of character. I thought I taught you to be a gentleman! Do you know the minuet, darling?" Then she lifted her skirt a bit and began to dance slowly while he sat there bug-eyed. A short while after this, despite her protestations that he was making a big mistake, he terminated his piano lessons.

For the next four years M. and Charles corresponded, her voluminous letters full of love and adoration, expectation and advice. He relished the attention and her poetic, lyrical French way of expressing it — "*mon amour, mon trésor.*" Finally, feeling she could no longer live without him, M. flew to Montreal to stay with him while he was working at Expo 67. Since Rick Salutin and his wife Melanie Conn were visiting Charles at that time, the four of them shared a one-bedroom apartment, overlooking Parc Lafontaine, by hanging a sheet between the two beds. It was an ambivalent and confusing experience for Charles.

That summer he took M. to Toronto, introduced her to his friends, and drove her up to the family cottage on Lake Simcoe to meet his parents. Charles and M. had a particularly sensual, effortless tryst in a glade full of trilliums beside a farmer's field behind the cottage. Despite the good times they still had, by the time he drove her to the airport in Montreal, he was relieved that she was going back to France. A year went by and they continued corresponding.

Charles had flirted that winter in Montreal with J., the attractive sister of his house-mate, André Ostiguy. He didn't get involved with her, thinking that the woman he really wanted to be with was M., so he flew back to France. The moment he saw her, however, he felt a knot in his stomach. He wasn't sure what it was, but something didn't seem right.

They stayed in her cozy student residence in Fontenay-sous-Bois, a suburb south of Paris, jumped into bed, and made love immediately, easily, mechanically. Then they took a train south to her hometown of Montceau-les-Mines, a plain little town in Burgundy, where he stayed with her in her mother's frugal new high-rise apartment building. Her gentle mother fed him *une omelette aux girolles* with a fine wine.

Hoping he had come for her daughter's hand, she proudly showed him the one family heirloom, a ponderous Louis XVI armoire, which she hinted would be part of her daughter's dowry after they married. They took walks through towering

Burgundian forests, picking mushrooms, and driving around in M.'s miniscule rear-engine Simca.

Feeling he was living a lie being with her, he eventually told M. the truth, that he was attracted to men.

"This can't continue. This won't work," she responded. "Love is a sacrifice two must make. When will you get over these fantasies?"

After a few days of this, he thanked M. and her mother, made excuses, and boarded a train to Lyon. She waved slowly with her handkerchief as the train pulled away. He never saw her again.

Charles flew to Athens from France and took a boat to Mykonos, where Barry Zaid, an old friend from Toronto, was living an openly gay life. Struggling with the gay fantasies Charles had had throughout adolescence, he had a personal crisis while at that island, surrounded by beautiful young men strutting their stuff. He felt miserable and dejected, as if he had failed at something he thought he wanted desperately. Depressed, Charles came home to Canada and decided to see Dr. Sam Jedwab, a Polish-Jewish psychiatrist recommended to him by Rachel Cavalho. Charles knew he had fled from something that needed explaining, and he entered therapy for the next two years.

For two decades Charles slept with women. One was G., a plump, blond English girl he met when she worked in the office at Camp White Pine. She used to visit him every night at his cabin. One night he made a roaring fire and spread out an old red velvet theatre curtain on the floor, which they used as a mattress for lovemaking. In the fall she returned to England, but she later flew back to North America to resume their affair, tracking him down at the Cranbrook Academy of Art in Michigan, where he was working on his MFA. After being turned away from a motel, they sneaked into his dorm room. To his surprise, her lovemaking interests had changed. She removed his belt and started whipping him. Deciding this was not his cup of tea, he put her on a train to Detroit and said goodbye to both G. and his belt.

At Cranbrook, he met B., an all-American, spirited, cheerleader-type from Alpena, Michigan. Charlie called her Bubbles and she called him Chuckles. Bubbles played the part of his devoted girlfriend whenever his parents visited, the role ending when the two of them graduated.

V. was a pert, pixie-ish WASP from Toronto with curly black hair and big eyes, whom Charles first met at the Ontario College of Art. Years later they met again when she was living in a cottage on Heath Street. She invited him for dinner, and they ended

up making love under the dining table. Their brief affair was memorialized by a friend of hers, Warren Collins, from the CBC. Collins made a short film of the two of them doing Fred Astaire and Ginger Rogers routines, dancing on the roof of the apartment building next door to songs by Cole Porter and Irving Berlin.

S. was a pretty, young Canadian divorcee, with big blue eyes, full lips, and short hair, whom he first met in France. One winter weekend, while they were at his family's cottage near Orillia, they had sex in his parents' bedroom. While she whispered in his ear, "You are so erotic," all he could think about was that he was making love to a woman in his mother's bed.

R. was the last woman Charlie slept with. While on a tour of Israel, led by his mother, the two of them sang "Hava Nagila" in the back of the bus in Tel Aviv while the bus driver kept asking him, "So, Charlie, when you going to marry her?"

Charlie's first adult gay experience occurred when he was about to turn twenty-one. He was invited by a couple (who were friends of his uncle) to their lodge in Fenelon Falls for Christmas dinner. It was cold and snowy, Christmas decorations were everywhere, tables were covered in red cloths, and holly and mistletoe hung all around the room. Charles brought with him his U of T student friend and painting buddy, Ed Roman. There were only a few other people there, one of whom was R., a tall, dark, good-looking thirty-something man who made a habit of sitting next to Charlie and eyeing him intensely.

Charlie was doing his shtick after dinner, making flippant remarks about Christmas and what it was like to be Jewish at Christmastime. R. feigned offence at his satire. Suddenly, Charlie was aware of R.'s leg pressing against his. He pretended not to notice. Though he felt slightly uncomfortable, he also felt mildly aroused.

As the others grew tired and left to go up to their rooms, Charles found himself momentarily alone with R. He was leaving to go up to his room when R. approached, inviting him for a nightcap in his room, just to let him know he wasn't really annoyed. Reluctant at first, Charlie went with him, suspecting that R., had something planned. R. poured him a tall straight scotch. Charles drank it quickly and soon felt giddy and helpless. R. seduced him immediately. Charlie pretended to be offended, but he found himself helplessly attracted to R. who pleasured him in ways he had never felt before.

Drunk and ashamed, Charles skulked off to his own bedroom. The next day Charles gave Ed a sob story about what happened. Ed, ever to the rescue, decided they

should leave. R. appeared at breakfast, smiling conspiratorially. As they were leaving, R. said he would contact him in the city.

Charles went back to the city with an outward moral stance of righteous indignation, all the while waiting anxiously for his call. When R. called a few days later, Charles's curiosity, now at a pitch, got the better of him, and he went to see R. in his posh townhouse on Charles Street. Once again Charles felt a rush, a high, as R. plied him with drinks, dressed him in silk pajamas, led him to bed, and began making out with him. Suddenly he was aware that someone else was in the bed. It turned out to be the husband of the couple with the lodge in Fenelon Falls. This was a preplanned threesome. Charles felt betrayed, dressed quickly, and skulked out for a second time. Despite R.'s many calls, Charles refused to see him again.

Alfred Kinsey, in his landmark book *Sexual Behavior in the Human Male*, argues, as had Havelock Ellis and Magnus Hirschfeld before him, that homosexuality is a normal variant of human sexuality. But the American psychiatric establishment had decided that homosexual behaviour was pathological, a decision influenced by the popularity of Irving Bieber's book *Homosexuality: A Psychoanalytic Study of Male Homosexuals*. Bieber's thesis was that most homosexuals with a strong motivation to change could do so with the help of a knowledgeable therapist. Homosexuality was therefore considered a treatable illness, from which one would eventually recover as soon as one met the right woman. Charles thought this was heteronormative prejudice, but Dr. Jedwab tried to get him to accept and deal with it.

"How goes the struggle?" Dr. Jedwab would often ask Charles when he entered his office.

A book Charles read twenty years later, *Cures: A Gay Man's Odyssey* by Martin Duberman, helped him to eventually come to terms with his gay identity. In the early seventies, Duberman had confronted the prevailing psychoanalytical view that depicted gays as neurotics, truncated by domineering mothers and distant fathers. But when Duberman assured gays that all they really needed was a loving, supportive partner to find happiness, Charles went from anguish and denial to a measure of self-acceptance. The year homosexuality was finally removed from the *Diagnostic and Statistical Manual of Mental Disorders*, Charles, then thirty-one, told his friend Judy Stoffman, "See, there's nothing wrong with me."

In 1975 Charles invited the Toronto Dance Theatre to a post-performance party he hosted at his studio at 24 Ryerson Avenue. That night he met a lithe, red-headed dancer, D., with whom he had an affair for the next four years.

Soon after, while visiting his father, Charles told him that he had had straight relationships over the years, but "I've come to the realization at age thirty-five that gay relationships mean more to me."

When he was forty, Charles held a party for fifty gay friends and acquaintances on the roof of his studio at 2 Grange Place, inviting Dibbles, hoping she would relate to the group. Her friends later told him how proud she was of him, and that she was delighted to attend the gallery openings and other events he hosted. In another of her great one-liners Dibbles announced to the members of her bridge club, "After all these years, I think Charles has finally come out of the cupboard."

Charlie visited Rick Salutin and Melanie Conn at their apartment on Riverside Drive when they were living in New York in the 1970s.

"I told him, 'Rick, I think I'm gay.'"

Rick replied, "So what."

When Rick's novel *A Man of Little Faith* was published, Charlie saw that one of its characters was a thinly disguised version of him. It mentioned, "James, once Jimmy, maker of the ark. A sculptor. I have followed his career. There is something sexually ambiguous about him — he is not comfortable with it."

"How could you do this?" he implored Rick, "There's a character in the novel who's a gay artist. Now everyone will know it's me."

Rick replied, "Who doesn't know? Besides, it's fiction."

They ended up not talking to each other for the next couple of years. The rift ended the day they went together to a state dinner held by Prime Minister Brian Mulroney to celebrate Nelson Mandela's release from prison.

CHAPTER 7

Graduate Studies

Charles's U of T studio professor, sculptor Ted Bieler, had studied at the Cranbrook Acacdemy of Art in Michigan. When Charles was trying to decide where to do graduate work, Ted suggested he visit Cranbrook before making a decision. Charles drove there and was charmed by the elegant campus north of Detroit, with its mid-century modern studios and galleries. He loved everything "from the Bauhaus-inspired workshops to the 'Arts and Crafts' country homes and cottages, which were surrounded by fields of golden daffodils Wordsworth would have liked." Charles was smitten, applied to the school, and was accepted into the two-year MFA program.

The sprawling campus began as a 174-acre farm purchased in 1904 by George Gough Booth, a Detroit newspaper baron and philanthropist. Booth hired Eliel Saarinen, a Finnish architect who played a major role in the history of modern American design and architecture, to design the campus. Saarinen and architect Albert Kahn were inspired by the vision of the Arts and Crafts movement, which began in England in the mid-nineteenth century and soon spread to the United States. Booth hoped its influence would banish tasteless, mass-produced goods from American homes. Notable alumni and faculty of Cranbrook included Charles Eames, Florence Knoll, Daniel Libeskind, Eero Saarinen, and Keith Haring. As one of only twelve students in the graphics department, Charles lived in residence on campus for two years, working in lithography, silkscreen, and etching.

While a student at the University of Toronto in 1962, Charles had begun corresponding regularly with Margaret Atwood. After he sent her some of his silkscreen prints when she was studying at Harvard, she wrote back:

> Have you ever made a sensation here. My fine arts roommate is mad about your prints. She thinks you are loaded with talent, versatile, perceptive and creative. Also, she would like to buy some. (I don't think she can afford more than 10 and would probably find it easier with less.) Also if she buys she would like them signed and dated. Obviously she thinks you are going to be famous, couldn't you die?[1]

The roommate did buy one, but fame would have to wait.

That time came later when, in a fateful gesture, Atwood wrote to him at Cranbrook to ask if he would consider illustrating *The Circle Game*, a series of eight poems she had recently written. She sent him a copy of the poems and Charles fell in love with them immediately.

Charles printing a lithograph with Atwood poem at the Cranbrook Academy of Art, 1965.

ii

Being with you
here, in this room

is like groping through a mirror
whose glass has melted
to the consistency
of gelatin

You refuse to be
(and I)
an exact reflection, yet
will not walk from the glass,
be separate.

Anyway it is right
that they have put
so many mirrors here
(chipped, hung crooked)
in this room with its high transom
and empty wardrobe; even
the back of the door
has one.

There are people in the next room
arguing, opening and closing drawers
(the walls are thin)

You look past me, listening
to them, perhaps, or
watching
your own reflection somewhere
behind my head,
over my shoulder

You shift, and the bed
sags under us, losing its focus

There is someone in the next room

There is always

(your face
remote, listening)

someone in the next room.

Page from *The Circle Game*, 1964, handprinted by Charles Pachter, Cranbrook Academy of Art.

He printed the poems on an antique letterpress and the accompanying lithographs on a flatbed press. He made paper by hand, using chopped-up blue jeans, pillowcases, pajamas, and strands of hair, which he still had plenty of at the time, to create the textured end papers.

A month later he sent the completed folio to Atwood. "Well, it is finished. I've never felt so good about anything in my life as I do now…. God how I wish I could be there when you get it."[2]

She loved his illustrations but insisted "It would not, I repeat not, be a good idea to show it to my parents. The subject matter of the poems would disturb them."[3]

Going into more detail about her feelings and her response on receiving his work, she told him, "I was so excited. I just took it out into the hall … is it ever a stunner. I have already shown it to a couple of people; Earle Birney (poet) one, great excitement…. So you get 2000 gold stars."[4]

The Circle Game, handprinted in an edition of only fifteen copies, was a breakthrough for both of them. One copy was later purchased by Guy Robert for his Musée d'Art Contemporain in Montreal.

The Circle Game was followed by four more handmade books that Charles printed at Cranbrook: *Expeditions*, *Kaleidoscopes: Baroque*, *Talismans for Children*, and *Speeches for Doctor Frankenstein*. In a note to Atwood that he wrote accompanying the copy of *Kaleidoscopes: Baroque* he sent her, Charles wrote:

> Here's the little "trinket" I've been working on. I thought the poem was suited to a tiny format. Note the little grey and black hairs throughout. They're mine. I wanted them for texture. The paper is made mostly from linen table napkins cadged from restaurants and a few bits of unmentionables. I hand-bound this one using leftover pieces of linen canvas given to me by painters here.[5]

Atwood wrote back, "I showed the book to a poet here today and he took one look at #4, the nekkid lady, and said 'Is he in love with you?'"[6]

Later that year, in response to Charles's gift of a housecoat (with a Princess Peggy label) for her, Atwood wrote, "You certainly have a natural eye for the UGLY. The housecoat you sent does indeed go with my wallpaper; and it sort of fits me too.... Where did you get it? I guessed Honest Ed's."[7] She guessed right.

Atwood had the ability to push buttons in Charles's psyche that he didn't know existed. She was instrumental in boosting his self-confidence as an artist, always telling him she couldn't wait to see his next image. His love for her in return was unconditional. Atwood was his muse and mentor. She nurtured him, extolled his work, and advocated for him constantly.

Charles was not only learning how to produce fine art at Cranbrook, but he also gained valuable experience in marketing and selling his work. At their graduation sale at Cranbrook in 1966, other students set prices for their art ranging from $500 to $1,000. Not Charles. With emerging entrepreneurial intuition, he set a price of $50 each for the forty expressionist prints and drawings in his portfolio, and he sold them all.

His graphics instructor, Laurence Barker, who was impressed not only by Charles's skill as an artist but also by his savvy as a salesman, asked him, "Why are you going back to Canada? You should go straight to New York."

Charles replied, "I love my country. I want to spend my life raising the bar there."

7/15 Funny What Love Can Do Pachter '66

On Charles's return to Toronto, he rented an old grocery store at 907 Shaw Street and transformed it into his first live-work home and studio. He rented the bedrooms above the store to his old friend Ed Roman, the glassblower, and a couple of draft dodgers from the States.

Charles purchased an old lithographic press and began working on a new series of prints. He showed them to Doris Pascal, the owner of the first gallery in Toronto devoted to graphics. As a result, he was given the opportunity to show his expression-istic self-portraits in November 1968. He sold over a dozen of his anguished images. It was during this period that Charles displayed his political opposition to the war in Vietnam with poignant lithographs, such as *We Must End the Killing*, which depicted

Funny What Love Can Do,
lithograph, 1966.

We Must End the Killing, lithograph and silkscreen, 1968.

a pompous politician in dark glasses, and *Encounter*, which showed a student gritting his teeth, confronting a cop on the Kent State campus.

Not only was Charles at odds with the politicians behind the war in Vietnam, he found that he was also out of sync with the bureaucrats behind the arts funding agencies at home. With his request for yet another Canada Council grant rejected, Charles wrote to Atwood, "Dibbles says I'm the most successful failure she knows."[8]

Atwood replied, "Never mind, you'll get your own back in Futurity when the Pachter-Atwood correspondence comes out in gilt-edged … They'll roast in HELL and you will be painting God's Murals in the Sky."[9]

Meanwhile, however, Atwood's career was taking off. "Well, guess all my friends will hate me now that I've won the Governor General's," she wrote, adding, "(at first I thought it was you playing a practical joke)."[10]

Giacometti sculpture, Expo 67, Montreal.

At this time, Charles decided that he wanted to be part of the World's Fair that would be taking place in Montreal the next year.

Expo 67, Canada's main celebration during its centennial year, had been intended for Moscow, to help the Soviet Union mark the Russian Revolution's fiftieth anniversary, but the Soviets opted out of hosting the event, and Canada was awarded this official World's Fair in late 1962. Opening ceremonies were held on April 27, 1967, with Governor General Roland Michener and Prime Minister Lester Pearson presiding. Nearly seven thousand media and guests, fifty-three heads of state, and over seven hundred million viewers and listeners witnessed the event. Visitors included Queen Elizabeth, U.S. President Lyndon Johnson, Jackie and Bobby Kennedy, Bing Crosby, Harry Belafonte, Maurice Chevalier, and Marlene Dietrich. President Charles de Gaulle of France caused an international incident when, on July 24, he yelled from Montreal's City Hall, "*Vive le Québec libre!*" The best example still remaining of Expo 67's buildings is Moshe Safdie's architectural marvel, Habitat.

When Charles first heard about Expo 67, he decided that, twenty years after starring in *Johnny at the Fair*, he absolutely had to be there. He turned

down a job he was offered to supervise the miniskirted hostesses at the Ontario pavilion. Charles's job application then ended up on the desk of Guy Robert, the curator who had bought *The Circle Game* for Montreal's Musée d'Art Contemporain a year earlier. He became assistant to Guy, now the curator of the International Exhibition of Contemporary Sculpture. Charles helped install sculptures by Picasso, Giacometti, Rodin, and sixty other renowned sculptors from around the world on the sloping site

Charles with Alexander Calder and Calder's monumental sculpture on Inco Plaza, Expo 67.

surrounding the American pavilion on the Île Ste-Hélène. In addition to supervising the pouring of the concrete bases and the placement of the sculptures, he checked and reported on the condition of each sculpture on a weekly basis. He also translated the French catalogue into English and brought meals on site to the great American sculptor Alexander Calder, who had come to Expo to supervise installation of his monumental stabile on the Inco Plaza.

On his days off he checked out the architecture, the national pavilions, and the man-made site, convinced that Canada had finally become glamorous. Charles also found time to print lithographs in Atelier Graff, Pierre Ayot's studio on Rue Rachel, and drink in noisy bars on the Rue St-Denis to discuss separatism late at night with his Expo colleagues. He spent weekends in the Laurentians with his boss, Guy Robert, and visited poet Cécile Cloutier in her elegant eighteenth-century farmhouse at Neuville overlooking the mighty St. Lawrence.

While Charles was in Montreal, he received letters from Margaret Atwood, who was in Boston. She reassured him, "Forget about the critics and follow your own intuition — if the critics approve, fine, otherwise they just aren't plugged in to what you're doing. Critics are specialized just like artists — you'll simply have to wait until the RIGHT ONE COMES ALONG."[11]

CHAPTER 8

A New Start

On his return to Toronto from Montreal after Expo 67, Charles purchased his first house at 1232 Shaw Street for $26,000. Without any formal architectural training, he gutted and rebuilt it, discovering the pleasure of reconstructing interior space organically. The approach was similar to working on a painting. Light source, scale, proportion, and colour were as important in constructing living space as on canvas. Charles set about creating a neighbourhood enclave, enticing everyone from Margaret Atwood to actress Maya Anderson, and Janet and David Hunter, into buying houses on nearby Marchmount Road. He organized volleyball tournaments, pitting the Marchmount Morons against the Shaw Street Crybabies. The multicultural street life here was invigorating and reminded him vaguely of Paris.

At the 1968 exhibition of his graphics at Gallery Pascal in Yorkville, he showed some of his best new work, including *It's Just a Flesh Wound, Champêtre, Invocation,* and *Is the Pope Catholic?* Charles was described by critic Gail Dexter Lord in the *Toronto Star*, March 23, 1968, as "a fine craftsman who achieves delicate washes and strong expressive lines with equal facility. There is a sense of terror in these works which is communicated on the most visceral level. His work is beautifully complex, the symbolism of the child's world, the fantasy of woman, the tenor of death reflected in life-like images, graceful line, brilliant colour and mysterious veils."

That year Charles also began illustrating and printing the works of Canadian poets John Newlove (*Notebook Pages*) and Alden Nowlan (*A Black Plastic Button and a Yellow Yoyo*), both of whom had been suggested to him by Atwood. Charles was developing more contacts and producing some of his best work yet, so he began selling his work himself.

Artists generally have to live with career disappointments, and although he'd been turned down for a grant by the Canada Council ten times between the years 1964 and 1973, Charles soldiered on. Years later, after obtaining a $500 tax receipt from the Thomas Fisher Rare Book Library for his rejection letters, his mother exclaimed, "See, it wasn't a total loss!"

Not the kind of guy to identify as a helpless victim, Charles rejected the Romantic stereotype that to be an artist one must suffer. As a young artist, he once asked Atwood if she though you had to suffer to be an artist. She replied, "I tried suffering, didn't like it."[1] And neither did he.

Charles was delighted, therefore, when Richard Johnston, Dean of Arts at the University of Calgary, offered him a job as assistant professor in the Art Department. Charles drove his little Envoy Epic to Calgary, discovering the vastness of the country along the way. His exposure to treeless open spaces propelled him away from his internalized expressionist examinations of his life in his earlier work to a new appreciation of the external world. As a young, urban, middle-class easterner, thrust suddenly into the light of prairie skies, mountains, and the magnitude of western vistas, his romantic notions about Canada found a new vocabulary.

It was after moving into a small rented frame house at 1501 21st Street SW in Calgary that Charles first explored the Canadian psyche in his art. He began creating images of Mounties and cowgirls as pop-art icons hovering over prairie landscapes. A fine example is a 1969 lithograph *We'll All Be There to Meet Her*, with a huge, smiling cowgirl looming over the prairie.

While in Calgary, Charles received more bad news from Dennis Lee, the intended publisher of the Atwood-Pachter opus, *The Journals of Susanna Moodie*: "… the Canada Council executive isn't willing to support it to their board…. Send the hemlock to the Council or Anansi or wherever, just don't use it on yourself!"[2]

On learning of the council's decision, Atwood wrote him, "Your not getting the grant is the most grotesque thing ever heard of and convinces me that the spirit of Silcox remained after the departure of his body."[3]

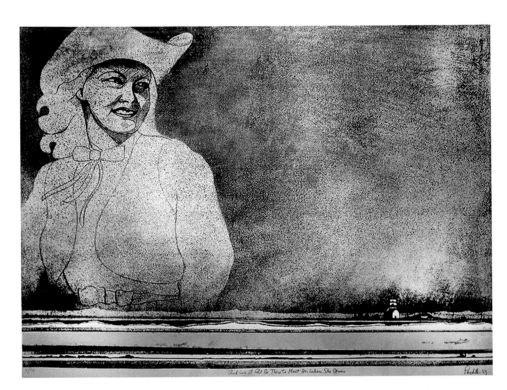

We'll All Be There to Meet Her, lithograph, 1969.

Charles and Margaret Atwood at his opening at the Canadian Art Galleries, Calgary, February 1970.

Fortunately, a gallery in Calgary recognized his work and offered him an exhibition. At his Canadian Art Galleries show in February 1970, Charles wore a 1950s vintage tux with sequined lapels and spectator shoes, purchased at the local Sally Ann. Atwood, who was living and teaching in Edmonton, came down to Calgary for his show primly dressed in high-button shoes, a maxi-skirt, and a feathered hat with half-veil, also purchased from the Sally Ann. Charles got A&W waitresses to serve super-thick milkshakes to the gallery's visitors.

Wendy Woodford, in her *Calgary Albertan* review of his show, described his print *It's Just a Flesh Wound* as a "painful, terrifying head in strong colours drawn over with a myriad of shocked lines looking like exposed nerve endings."[4]

When his year in Calgary ended, Charles drove back to Toronto and settled back into his studio, continuing to explore Canadian pop culture in his paintings. In the U.S., Andy Warhol was painting Campbell's soup cans, and Jasper Johns was painting

It's Just a Flesh Wound, lithograph and silkscreen, 1968.

American flags. *Canadian Art* was featuring articles about American pop artists like Rauschenberg, Rivers, Wesselman, and Oldenburg. Meanwhile, Charles was turning Toronto's streetcars into pop icons.

The image of the streetcar may have come from a childhood incident, when Charles sent away two Shredded Wheat cereal box tops to Nabisco in Niagara Falls. In exchange for the two box tops, the company promised a genuine cardboard streetcar that you assembled yourself. But it never showed up. More likely his visit to the Wychwood Avenue streetcar barns ignited Charles's interest in these huge, brightly painted metal carcasses, standing silent and empty. The iconic streetcar is represented variously in

Streetcar Headdress,
serigraph, 1972.

some of his graphics; one ascends to heaven, another floats on the surface of a lake, one has self-erected, and another reproduces itself into a fan-shaped headdress.

Charles continued to note that, in the media, Canadian art was generally considered inconsequential compared to art from elsewhere. So he decided it was time to study more about how history shaped the Canadian mindset. In an effort to understand Canada's post-colonial psyche, Pachter read history books about New France, the Conquest, Wolfe and Montcalm, the Loyalists, and the Family Compact, all of which eventually led him to a series of paintings about John Graves Simcoe and Upper Canada.

Despite all of these efforts, the Canada Council had still rejected him for the publishing grant for *The Journals of Susanna Moodie.* Charles, however, continued on. At the request of art dealer Av Isaacs, Charles flew two thousand miles north to Cape Dorset, on Baffin Island, in the dead of winter, December 1971. Foolishly wearing just a leather windbreaker, he had been sent north to teach lithography to the Inuit people of the West Baffin Eskimo Co-op. He took with him instructions for assembling the parts of the printing press he had previously sent them. When he arrived, he found they had already assembled the press and were ready to print lithographs of motorcycles and guns. The first thing Terry Ryan, director of the co-op, told Charles was that they should be making lithographs of igloos and seals that would find a ready market back in Toronto.

Such issues were not the most important ones, though. Charles noticed that many of the Inuit were suffering from tuberculosis and were spitting into little tin cups.

When he got very ill himself, Charles wrote to a friend, "My voyage to death valley ... is certainly one of the worst moments I have ever lived through."

He lasted two weeks before he succumbed to pneumonia and pleurisy.

The letter continued:

> Aside from the delirium, [I have] white froth caking around mouth and lips, [am] peeing brown, [have] dry retching, fever, hallucinations, eyes sinking in their sockets. I was sickened to see how quickly my resistance broke down ... in the middle of the night at 40 below zero in the blackness and stillness all alone in my stinking little bedroom ... I saw it all pass before me — my life — doubting I'd ever get out of that isolated outpost alive. They call it "being bushed".... I was hallucinating even more in my hotel room in Frobisher Bay ... I spent the next 5 days there on intravenous and antibiotics, then was flown to Montreal, spent two days at Montreal General Hospital, was driven to Toronto by my Montreal cousins and spent 2 weeks in Toronto Western Hospital to gain back about 25 lbs I had lost from dehydration. So I'm home and ALIVE...[5]

If it had not been for a nurse up north, who recognized he had pneumonia and loaded him up with antibiotics, he may not have lived. According to Dr. Stan Epstein, who later saw Charles at Toronto Western Hospital, that nurse saved Charles's life.

Charles did eventually recover and get back to work. He continued to explore the image of Toronto's streetcars in a number of serigraphs that he showed to dealer Av Isaacs, who gave him a solo exhibition in April 1972.

> The show sold well, fifteen pieces, but after paying 40 percent to the gallery, and framing costs for sixty pieces, I came out at a loss.... About six hundred people showed up, and Av was astonished. He couldn't figure out who they were or how I had such a following. Neither could I. My relatives baked *mandelbrot* and brought them to the gallery, and Miriam Wilson made gingerbread streetcars which were snapped up like jewels.[6]

Along with the challenges Charles and other artists had in selling their works, there were other issues on the art scene. In 1972 Pachter participated in a protest at the

AGO, organized by left-wing activist Jim Brown. The AGO had hired an American, Richard Wattenmaker, as its new director, so twenty artists, writers, and filmmakers, including Charles, Michael Snow, Joyce Wieland, John Boyle, Greg Curnoe, Susan Crean, Jay Macpherson, Michael Hirsh, and Judy Steed, tied themselves with ropes to the front of Av Isaacs's gallery. In the ensuing days they dressed up to attend the AGO annual general meeting and made speeches about being denied shows at the AGO. For some obscure reason, they were also called Bolsheviks. Mrs. Walter Gordon and Mrs. Bea Davidson told them to get themselves elected to the AGO board. When they tried to meet with Richard Wattenmaker, he stayed behind the door of his office, refusing to see them.

Needing a break from the politics of the art world, Charles drove east to the Gaspé Peninsula in the summer of 1972 with some friends to witness a rare full eclipse of the sun. They sat in a fragrant green hayfield near Matane in mid-afternoon as the skies mysteriously darkened like in a medieval apocalypse, causing the cows to moo, the dogs to bark, and the sheep to bleat. The St. Lawrence River valley was a joy to drive through, and he soaked up the verdant landscape and sparkling waters, images he would later use in two signature paintings for the Queen on Moose series, *Procession Through Landscape* and *The Visitation*.

Charles and fellow artists protesting in front of Isaacs Gallery, 1972.

CHAPTER 9

Canada Rediscovered

When Charles read that the queen was coming to Niagara-on-the-Lake to open the new Shaw Festival Theatre in June 1973, it brought back memories from his childhood of earlier royal visits. He also remembered petting a moose at the CNE when he was four. He recalled public school lessons, when he and his classmates were taught about the animals of Canada. The moose had been referred to as the "monarch of the north." An idea came to him.

After examining stereotypical images of the moose and the landscape, he began working on what was to become, arguably, his best-known series of paintings. He depicted a wraith-like queen who, as Charles had written in his diary, "we didn't really know, who isn't one of us, who doesn't live with us, who doesn't visit very often, who doesn't speak like us. Yet we venerate her, probably for these very reasons." Charles's choice of the moose was a serendipitous symbol, "considering that it looks like it was created by a committee. It's an ungainly creature, with huge antlers and spindly legs. Elusive, rarely seen and usually somewhere in the wilderness near the shores of remote lakes, it's a poignant and majestic creature, an elusive loner that doesn't travel in packs. To many it's the shy, masculine symbol of the untamed north."

Charles's intention was to elicit a subtle reaction from the viewer, not a guffaw. His fascination with royalty led him to start depicting Her Majesty in Canadian settings. From these exploratory images there emerged the signature painting, *Noblesse Oblige*, now referred to as *Queen on Moose*, featuring the queen taking the salute on mooseback. The two monarchs have developed a symbiotic relationship in a Canadian context. As art historian Douglas Richardson eloquently expressed it in the AGO

catalogue for *Collins, Pachter, Tinkl* (1977), "The theme of identity runs through his work, the moose as symbol of national identity and by extension of himself. A myth-maker as well as printer and painter, his works are witty and ironic but also gentle, wistful and bittersweet."

After *Queen on Moose*, several images came in succession. *Procession Through Landscape* featured a disembodied glove seen from inside a limousine. This arose from

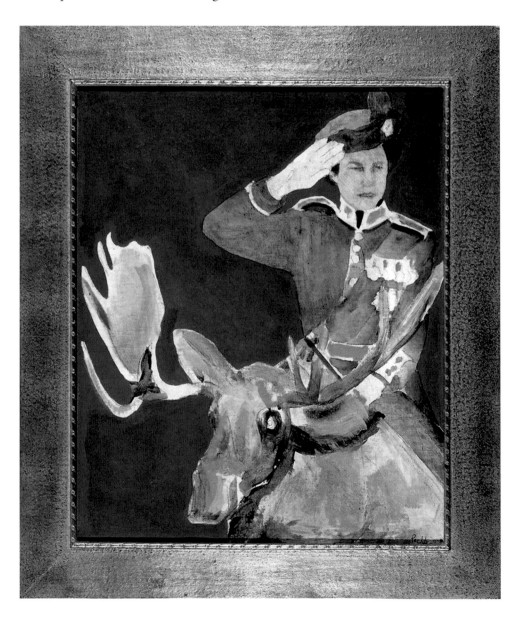

Noblesse Oblige, Queen on Moose, acrylic and pencil on canvas board, 1972.

(Private Collection, Toronto.)

childhood memories of sitting on his father's shoulders waiting impatiently in the street for the royal cavalcade to appear. When the limousine finally sped by, all he remembered seeing was a glove. Another large canvas, *Rite de Passage* portrays a bejewelled queen in full regalia — crown, fur stole, and evening gown — waving from the back of a Canadian Pacific Railway caboose hurtling through a stylized Group of Seven forest at night. Eventually he removed Her Majesty from the scenario, and created a series of paintings of the moose alone, the first of which was *Monarch of the North Emerging from the Loins of the Sleeping Giant.*

It came as quite a blow to Charles when Av Isaacs chose not to exhibit the Queen on Moose series, telling Pachter, "You know why." The Isaacs Gallery had been criticized for showing works of Mark Prent that featured pickled human body parts in butcher cases. Av decided that Charles's "Monarchs" show would be too risqué for him. So Charles decided that, since his house was on Shaw Street, he would mount his own exhibition there.

Rite de Passage, acrylic on canvas, 1973.

(University College, University of Toronto.)

He opened it the same day the queen was in Niagara-on-the-Lake opening the new Shaw Festival Theatre. Charles called his show *The Other Shaw Festival*, and the centrepiece of the show was his painting of the queen and a moose entitled *Noblesse Oblige.*

Charles's friend and collector Larry Brenzel had an antique Rolls Royce, which he parked at the curb of 1232 Shaw Street. Brenzel got his wife, Sally, to sit inside it and, in regal hat and gloves, she waved obligingly to passersby. Margaret Atwood, Judy Stoffman, and Sara Cummins, all appropriately attired in summer party dresses, served tea on the lawn. The event was delightfully mischievous and the media picked it up with a barrage of local and international press coverage. Headlines like "Canada in Royal Rage over *Queen on Moose*" and "Monarchists Threaten to Slash Canvases" appeared in the *Toronto Star* on June 21, 1973, as well as in scores of newspapers worldwide from Johannesburg to Los Angeles.

Pachter sent an invitation to the queen and got the following letter back: "Unfortunately I must inform you that it has not been possible to arrange for Her

Majesty the Queen and His Royal Highness the Duke of Edinburgh to attend."[1] This whimsical fantasy, with no malice intended, had suddenly become *outré*. It struck a nerve; Canada had a new post-colonial iconic pop image. But Charles didn't sell a single painting, and the show was ignored by the art establishment.

Critic Gary Michael Dault's reaction to this iconic painting was predictably hostile. In the *Toronto Star* of June 21, 1973, he wrote: "Here sits the picture, *Queen on Moose*, and it doesn't mean anything, short of a little boyish joke. Is that what art is about? Jokes? The result of course is weariness, the feeling that you've been cheated by the artist. Facility without purpose." What the humourless Dault may have overlooked is that art can indeed be the source of fun. Daumier was a noted satirist; René Magritte used visual puns and surreal jokes, where businessmen in bowler hats rained from the sky or held apples in front of their faces; and Marcel Duchamp turned a urinal into art.

Many called Charles's new work irreverent. One consternated monarchist, a woman from London, Ontario, phoned in to a radio talk show exclaiming, "This is a

Bay Watch, acrylic on canvas, 2014.

(Hudson's Bay Company, New York.)

disgrace. If the man feels this way, he should keep it to himself! He should go back where he came from," which was north Toronto.

Pachter started out as a highly expressive printmaker and political maverick who bared his neuroses and rattled off clever, biting attacks against the conventional art world. For a growing constituency of fans, Charles Pachter was becoming the *enfant terrible* of the Canadian art world. Warhol would have approved.

From an art history perspective, many precedents in painting exist of a female with an animal — Beauty and the Beast, Europa and the Bull, Leda and the Swan. Charles's paintings of the queen with a moose are part of that tradition, and they have found an appreciative group of collectors, despite the critics. In fact, thirty-five years after he painted the series, one of the signature Queen on Moose paintings, *Dressage*, was purchased by Bonnie Brooks, "Chief Adventurer" for the Hudson's Bay Company.

Brooks later told the Bay's owner, Richard Baker, about *Bay Watch*, Charles's painting of a moose with the Bay's signature coloured stripes in the sky. The Bay was so interested in the work that it bought Charles's original painting along with the rights to reproduce the image. The Bay has since sold blankets, cushions, towels, placemats, and mugs using Charles's painting as the source, and he has ended up with his images on display in one hundred stores across Canada.

In another bit of serendipity, the Ontario Ministry of Transportation asked Charles for permission to use one of his moose images for their moose-crossing signs that are located along highways throughout northern Ontario.

Many years later Charles had his own private rendezvous with a moose. He flew with his friends, Marcia McClung, John and Susie Stewart, Cliff Atkinson, and Ray Pladsen, to St. John's, Newfoundland, rented a minivan and set off on an eight-day

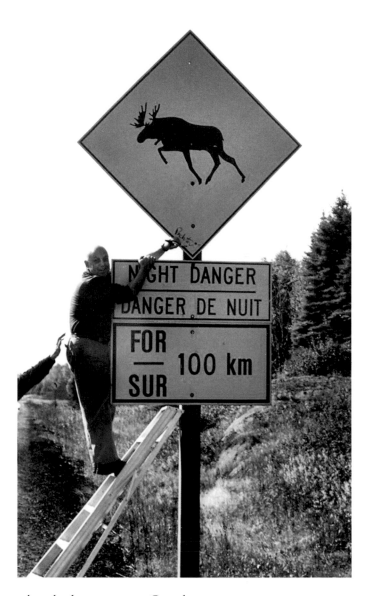

Charles with his moose sign on a highway near Wawa, Ontario.

odyssey. Everywhere they met charming, caring, friendly people, and drove through unexpectedly stunning vistas of forests, seascapes, and islands. At Trout River, they took a wilderness boat tour on a crystal clear lake surrounded by immense high cliffs and waterfalls. At one point, the captain slowed the boat down beside a pine-dotted hill where a magnificent bull moose stood its ground, guardedly checking them out. After eyeing the boat intuitively and deciding he had seen enough of them, the moose turned and trotted off into the bush. Moose warning signs were located along most of the province's highways. Charles later learned that there were more than 100,000 moose roaming Newfoundland, all descended from six that had been brought over from the mainland about a hundred years earlier.

CHAPTER 10

Ten Loft Years

Rosalie Silberman Abella, who had become a renowned lawyer (and who would later become a Supreme Court justice), held a dinner party in her home in the late 1970s. She invited, among others, William Thorsell, Gerry Schwartz and Heather Reisman, Jim and Heather Peterson, and Charles Pachter, all of them enjoying Abella's tacky taste in tchotchkes (trinkets). Rosie, as her friends and family called her, was another friend that Charles had made at Camp White Pine. When he first met her, she was a bright, funny seventeen-year-old girl who shared his interests in the piano and in Broadway shows. They have remained friends ever since.

During the meal, Rosie introduced him to her mother, Fanny Silberman, a real estate agent and a woman who would become one of the most beloved people in his life. They hit it off immediately and became dear friends. Fanny was honest, lively, kind, and maternal, and she had a great sense of humour. She encouraged him in his efforts to transform Queen Street West for his next ten loft years, between 1974 and 1983.

Having outgrown his house at 1232 Shaw Street, he sold it and bought his first building at 24 Ryerson Avenue, near Queen and Bathurst, naming it Artists Alliance. With a $10,000 loan from Atwood for the down payment, Charles was now the proud owner of a 12,000-square-foot building with parking for twelve cars, all for $100,000. He moved in to a 3,000-square-foot loft on the top floor, rented studios to fellow artists, writers, journalists — Gary Greenwood, Joyce Wieland, Gwendolyn MacEwen, John Lownsbrough, Judy Steed, and June Callwood among them — started a co-op gallery called Artery, and became janitor, landlord, consultant, renovator, mediator, and event organizer.

Poster for Artists Alliance and Artery, 24 Ryerson Avenue, 1974.

One day, Charles started to become curious about the abandoned building next door to 24 Ryerson. Its doors were sealed, so he climbed up the fire escape to try to find a way in and look around but was caught by a cop.

"What do you think you're doing?" inquired the officer.

Charles had enough presence of mind to mutter "I'm sorry, officer, but I lost my pussy cat."

The cop replied, "Okay, but just don't go in there."

The moment he left Charles sneaked in. What he saw was a derelict old building with high ceilings, dust floating through shafts of sunlight, a few pigeons flying around, and garbage strewn everywhere. It looked haunted, like a Piranesi etching. He realized immediately that this place would make a wonderful theatre.

With some detective work he found that the owner, a man named Sol Friendly, was in a sickbed in Toronto General Hospital. Charles told theatre director Paul Thompson about the building and convinced him that the two of them should visit Sol to see if they could make a deal.

As they entered his hospital room, Charles joked to Paul, "Do you want to step on his oxygen tube or should I?"

Charles schmoozed with the old man. "You're not in great health," he observed, "maybe it's time you let go of the place."

A few weeks later Paul got the building for $95,000, and Theatre Passe Muraille had a new home.

Two of the quirkiest shows that Charles dreamt up at Artists Alliance were inspired by an offhand comment from his mother.

Dibbles always used to tell Charles "Don't say people are ugly. Beauty is only skin deep." This view was severely tested, however, when she met the girlfriend of one of Charles's buddies. The girl was skinny, had buck-teeth and a bad case of acne, and her blouse, made out of sugar sacks, revealed hairy armpits. One look was enough for

Dibbles. She later turned to Charles and remarked philosophically, "You know, there's ugly, and there's gorgeous, and there's in between … but THIS is UGLY!"

That comment became the tag line for *The Ugly Show*, held at 24 Ryerson Avenue. Charles asked fellow artists and friends to donate the ugliest works of art they had made or could find. Atwood provided a clay egg cup she made in her ceramics class that Charles proclaimed to be ugly, someone brought a really bad night-school nude, and Charles's dad's painting of Toronto City Hall on black velvet got a prime spot. Badly illustrated record covers — one was called *Organ Capers* — were exhibited beside a forty-inch-long papier mâché finger with matching nose and lips. Black Sambo hot water bottles were available for $1.99 each or all 12 for $1.99. Trays of wax lips and teeth were passed around to sample.

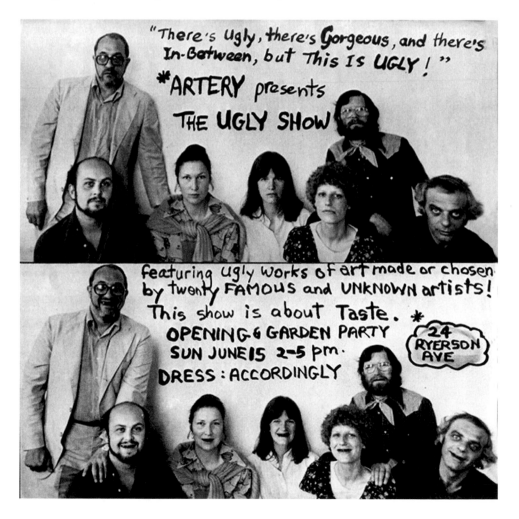

Invitation to *The Ugly Show*, 1975.

Charles wrote a totally incoherent program for the show, satirizing "art-speak":

THE UGLY SHOW
Introduction
By Clement Pearlstein

Diabolically the alternate development of this important ugly retrospective transforms spatial orientation into dark premonitions thrusting in mid-air as they struggle for the monumentality and tonality of the condor's foot, as it were, into the hapless void. Not unlike this apotheosis is this neither idyllic nor obsessive but rather tragic image of darkness and persecution. Here conflict of opposition is fully realized as an indictment in baroque and turbulent form belying amorous passion, as the Bull caresses Europa's hand, as it were. Indeed we are fortunate for these small mercies.[1]

The President and Board of Trustees of
Artists Alliance Building Limited
and the Board of Directors of

A R T E R Y

request the pleasure of your company
at the Official Opening of

THE STUNNING SHOW

an exhibition of exquisite and gorgeous
Works of Art by
prestige, well-established, name artists

Friday evening, Dress:
Feb. 6, 1976 Accordingly
8 - 10 p.m. Tickets:
24 Ryerson Ave. $300.00 per couple
 COMPLIMENTARY

Invitation to *The Stunning Show*, 1976.

Globe and Mail art critic James Purdie, taking it semi-seriously, felt it was the worst art show he had ever seen. Of course nothing sold.

A year later, *The Stunning Show* opened, at which Charles conned many of the city's elite collectors into showing up in tuxes and gowns for what they thought was an exclusive high society black-tie art auction fundraiser. The invitation stated "The President and Board of Trustees of Artists Alliance Building Limited and the Board of Directors of Artery request the pleasure of your company at the Official Opening of *The Stunning Show*, an exhibition of exquisite and gorgeous Works of Art by prestige, well-established, name, artists. Dress: Accordingly." With tickets priced at $300 per couple, each invitation was stamped "COMPLIMENTARY." The most frequently asked question from guests that night was, "Did you get a free one?" Seconded for the occasion were friends dressed as doormen, butlers, and maids. Every painting was priced at more than $100,000 (an astronomical sum for 1976).

Charles with guests at
The Stunning Show, 1976.

Charles choreographed his assistant Kathy Hogan and her sister Sandra, both dressed as French maids, to circulate amid the crowd with trays of hors d'oeuvres, and to move away whenever someone reached for one.

Charles sent himself congratulatory baskets of flowers he had obtained for free from a nearby funeral parlour, with cards bearing messages such as "Best Wishes, Pierre Trudeau," "Good Luck! Jack Bush," "Break a Leg, Harold Town," "Enchanting! Maureen Forrester," and "Way to Go! David Silcox." As for the art, on top of the astronomically priced paintings, there was a *Basic Moose* lithograph priced at $60, the *Economy Moose* was $100, the *Deluxe Moose* at $250, and the *First Class Moose* at $500.

Tenants and friends of Artists Alliance grew into an extended family. Charles invited them for summer weekends up to an old farmhouse and one-hundred-acre retreat that he purchased in Oro-Medonte Township, north of Barrie. He named it *Oro Fixation* as it was in need of major repairs. On seeing the farm, real estate agent (and Rosie Abella's mother) Fanny Silberman, who closed the deal, told him, "So now you're Duddy Kravitz."

Canada Day was always a big event at the farm. A special one took place in 1978, attended by, among others, Marilyn Lightstone, Moses Znaimer, Toller Cranston, Margaret Atwood and Graeme Gibson, Ruby Bronsten, Helen Lucas, Mary Geatros, Marci Lipman, Paul Oberst, Sandy Stagg, and Murray Ball. Escaping from hot lofts, the Queen Street troupe of painters, writers, filmmakers and friends would arrive in camper vans with kites, Frisbees, and picnic baskets, arranging themselves spontaneously in groupings for luncheons on the grass, accompanied by butter tarts bought from neighbouring church bake sales and Wilkie's Bakery in Orillia. Memories of these casual clusters led to a series of paintings which Charles completed a few months later, one of which, *Six Figures in a Landscape*, has been exhibited in France and Germany.

A year earlier the Art Gallery of Ontario mounted the three-person exhibition, *Collins, Pachter, Tinkl*, Charles's first showing at a major Canadian public art gallery. His sister's friend Glenda Milrod, a curator at the Art Gallery of Ontario, had visited Charles's studio, liked his art, and offered him a show with two other Canadian artists

Six Figures in a Landscape, acrylic on canvas, 1978.

(Private Collection, Toronto.)

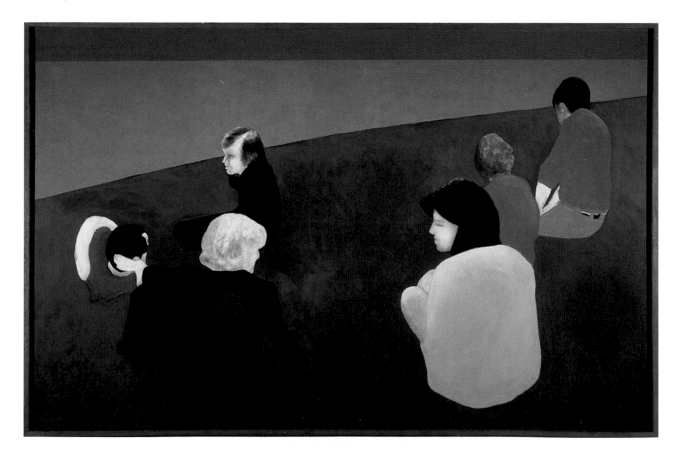

in September 1977. Though it took the consent of three different gallery committees before they agreed to show *Queen on Moose*, the AGO also exhibited what is perhaps Charles's finest painting, *Life Is Not A Fountain*, and made him feel for the first time that he was on a level playing field with other international artists. One of his paintings, *The Visitation,* an appropriated version of a medieval altarpiece by Giotto, featured two winged and haloed figures — the queen standing on a platform in the middle of a field, and her loyal subject, Mrs. E.P. Taylor, curtseying ceremoniously, with a moose grazing idly in the background.

Of the show, art critic Stephen Godfrey wrote, "Pachter's witty *The Visitation* is a masterpiece, a gentle joke featuring the queen in a composition reminiscent of medieval religious art, while moose and mountain goats wander through bleak landscapes replete with giant Canadian tires and low-flying toasters."[2] Pachter was glowingly described by Barbara Muir in *Artmagazine* as "a myth maker, creating great Canadian iconography out of everything from moose to streetcars to the height of the Canadian

The Visitation, acrylic and pastel on canvas, 1972.

(Private Collection, Toronto.)

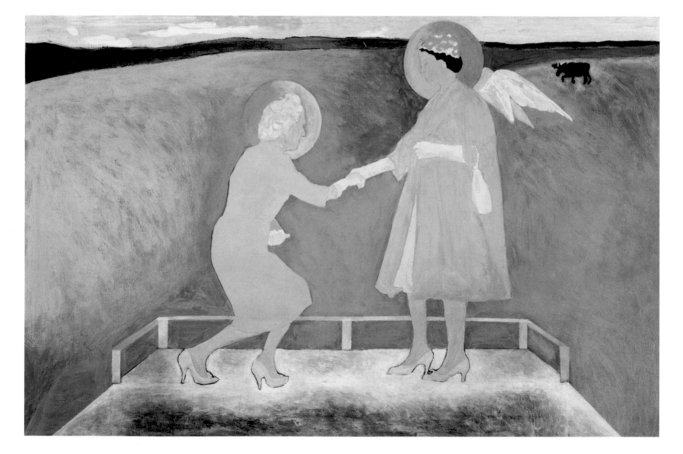

popular totem pole, the queen. His work ranges from pun to nostalgia, from humour to social commentary, seriously and humorously questioning what it means to be Canadian. In Pachter's world, the moose and polar bear become our animal spirits, symbolic representatives of the Canadian psyche."

At the same time Charles's career as an artist was flourishing, so, too, were his real estate ventures. Charles bought and refurbished the old Remenyi House of Music Building on Queen Street West at Augusta, opened a permanent loft gallery on the third floor, and hired a director, Judith Saunders.

A year later, he found and renovated an old fur factory at queen and Soho, renamed it the Soho Loft Gallery, and opened a solo exhibition called *Figures in a Landscape* in October 1979.

This show became his first commercial success. Meanwhile Artists Alliance was expanding so successfully that the company employed six people and managed a dozen properties with forty tenants. Queen Street West, with its second-hand shops, ethnic eateries, and spacious old warehouses, was being rediscovered. A new "village" was in the making.

CHAPTER 11

Home on the Grange

For several years Charles devoted himself to Artery, the artists' co-op he created at 24 Ryerson Avenue. But in time the novelty of loft life faded. He found large open spaces great for impressing friends and ideal for parties, but difficult to heat in winter, and impractical to live in. So he went looking for an alternative. A house seemed too small, a factory building too much work.

In 1977 Charles discovered an abandoned grocery store and blacksmith shop in a lane called Grange Place, at the corner of Sullivan Street, just west of the Art Gallery of Ontario. He knew immediately he had found what he was looking for. It was a grungy mess with ugly plastic curtains. At Fanny's suggestion, Charles inserted a clause in the Offer to Purchase that read "must include the drapes." He got the wreck for $42,000. The first thing he did was change the address from 2 Sullivan Street to 2 Grange Place, which sounded more elegant. Transforming the one-hundred-year-old building into a spacious residence and studio was a major challenge, but it proved to be worth it. A year later he had, at last, created an all-purpose environment where he could live and work comfortably and undisturbed, a block away from the burgeoning Queen Street scene.

Lorraine Monk, creator of the Canadian Museum of Photography in Ottawa and prolific photography book author, was one of his first guests. An elegant, sixty-year-old divorcee, she walked in one day wearing tight jeans and sweater, curled up on his couch, and coyly asked, "How much do you want for that painting of the queen on a moose?" When he suggested $2,000, she replied, "I'm not paying that. I'll pay you $5,000. This is the most important piece of post-colonial pop art created in Canada."

Before and after the renovation of 2 Grange Place, 1978–79.

Lorraine became his close friend and an ardent fan. She talked up his art to everyone, said one day it would be worth millions, visited him at his farm, his cottage, and his winter home in Florida, and attended his shows in Toronto, London, and Saint-Rémy-de-Provence in France. She told him, "We haven't got over that Victorian concept that you've got to be spitting blood before anybody pays attention to you. Thank God nobody ever told da Vinci that he couldn't invent the submarine and paint *The Last Supper*. I've been around artists all my life and as far as I'm concerned you're a genius."

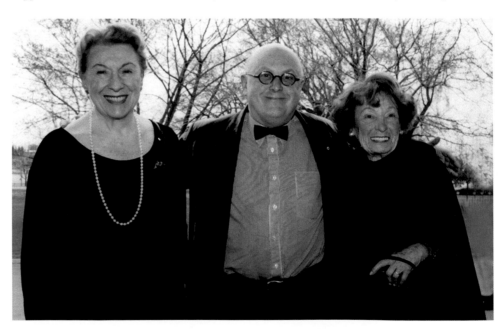

Lorraine Monk, Charles, and his mother Sara Pachter, 2003.

Many years later, in her late eighties, blind and immobile, she was bedridden, her fifty-seven-year-old husband Danny by her side when Charles paid her a visit.

"Sweetheart," Danny whispered, "Charles is here. You remember, *Queen on a Moose*?"

Eyes closed, she squeezed Charles's wrist and smiled. Charles shed a tear and quietly left the room.

Portrait of Lorraine Monk, acrylic on canvas, 1981.

CHAPTER 12

The Journals of Susanna Moodie

In March 1968, Margaret Atwood sent a typed manuscript of *The Journals of Susanna Moodie* to Charles when he was still in Montreal. It was a fateful moment. He read it and was so stunned by its beauty and power that he realized that all of the poems he had illustrated for her in handmade books up until then had been a rehearsal for this.

In 1832 a twenty-nine-year-old English woman named Susanna Moodie, who had already established a reputation as a writer of essays, poetry, and children's stories, departed for Canada with her family. Although possessing a degree of personal resilience, she was unprepared for the rigours of pioneer life. She did not let it overwhelm her, however, and chronicled her experience in her groundbreaking volume, *Roughing It in the Bush*. Moodie died in 1885, and almost a century later Atwood seized upon this quintessential pioneer as the subject for a verse epic, using Moodie's own words as raw material, reshaping them into a startling meditation on nature, alienation, and our sense of place.

When Charles returned to Toronto, he couldn't wait to get started. He began to work immediately on a maquette, or prototype, setting typefaces for the poems in different styles and sizes, cutting up and collaging proofs of earlier lithographs and silkscreens, then drawing on top of them to amplify the thematic imagery of the poems. By early 1969 Charles had completed the typesetting and draft images for the entire suite of twenty-seven poems, with a frontispiece and two introductory images, using an old Vandercook proof press he had acquired.

When he showed the maquette to Atwood, she enthused over it and suggested he show it to Dave Godfrey and Dennis Lee, who had recently founded House of

Anansi Press in Toronto. They were both eager to publish *The Journals of Susanna Moodie* and submitted a project proposal to the Canada Council. But it was turned down.

Atwood forged ahead and signed with Oxford University Press, which in 1970 published a small paperback version with some of her own unusual watercolour illustrations. A clause was included in her contract giving Charles the right to produce his deluxe version at any time. In November, a signed copy of the Oxford *Susanna* soon arrived in the mail for him. Atwood's inscription read: "To Charlie, with Regret, but Hope for the Future, Love, Peggy."

A few years later, the University of Toronto Library expressed interest in purchasing the maquette and subsequent printing rights for *The Journals of Susanna Moodie*. In early 1973, after writing to Atwood in London asking what she thought, Charles promptly received her letter back suggesting he hold on to it until the time was right for him to do it his way. Nearly a decade passed before that time arrived.

Charles with a print from *The Journals of Susanna Moodie*, 1980.

By chance, he learned that two Spanish master printers, Abel and Manuel Bello-Sanchez, were living and working in a neighbouring loft building on Niagara Street. They were experts in silkscreen, having printed editions in Europe for Salvador Dali and Robert and Sonia Delaunay. Charles called and arranged to meet them at their studio.

With the strong odour of French cigarettes and Spanish liqueurs wafting around them, they pored over the maquette, discussing various transferring and printing techniques. They cautiously agreed to sign on, providing their considerable demands were met. Soon the contract for cost of materials, printing, and payment schedules was drawn up and signed. Charles secured the necessary financing of $100,000 by borrowing against the equity in his loft buildings.

The calfskin boxes, handmade by binder Marion Mertens, cost $400 each, or $48,000 for the limited edition of 120 copies. Printing began in February 1980 and continued non-stop until October. The schedule was gruelling but exciting. The professional standards of the Bello-Sanchez brothers were impeccable. In the end, they printed over thirteen thousand separate impressions by hand. As part of the team, Charles was required to be one step ahead of them, preparing sketches for transferring to silkscreens for printing.

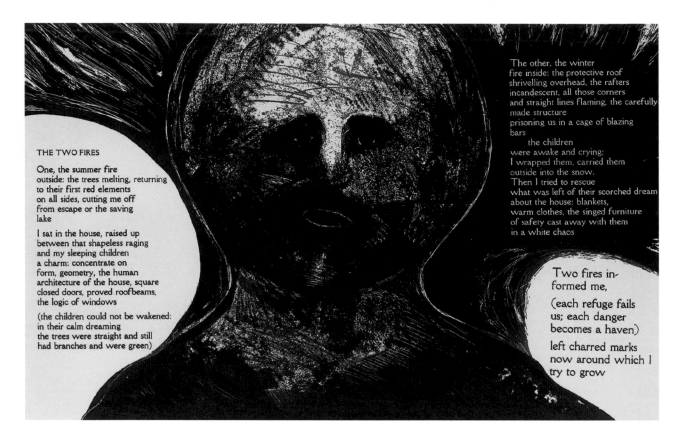

THE TWO FIRES

One, the summer fire
outside: the trees melting, returning
to their first red elements
on all sides, cutting me off
from escape or the saving
lake

I sat in the house, raised up
between that shapeless raging
and my sleeping children
a charm: concentrate on
form, geometry, the human
architecture of the house, square
closed doors, proved roofbeams,
the logic of windows

(the children could not be wakened:
in their calm dreaming
the trees were straight and still
had branches and were green)

The other, the winter
fire inside: the protective roof
shrivelling overhead, the rafters
incandescent, all those corners
and straight lines flaming, the carefully
made structure
prisoning us in a cage of blazing
bars
 the children
were awake and crying;
I wrapped them, carried them
outside into the snow.
Then I tried to rescue
what was left of their scorched dream
about the house: blankets,
warm clothes, the singed furniture
of safety cast away with them
in a white chaos

Two fires in-
formed me,

(each refuge fails
us; each danger
becomes a haven)

left charred marks
now around which I
try to grow

"The Two Fires," from
*The Journals of Susanna
Moodie*, 1980.

At first he worked hesitantly, but he soon went on automatic pilot. The ardour was contagious. While Manuel and Abel dragged ink across the screens with a squeegee, printing the words and the images, separately or together, Charles drew directly on the silkscreens with grease crayons and *tusche*, a suspension of greasy liquid that dried on the silk. It was later surrounded by glue blockout then dissolved with mineral spirits so ink could pass through where he had drawn. The rhythm of watching them print layer after layer, colour over colour, washing the screens, preparing new ones for him to draw on, stacking up the finished print runs, was intoxicating. They had an adrenaline rush each time a completed print was added to the growing ensemble.

Gradually the book took shape. Words and images began to complement each other sequentially. The poetry that Charles had hand set in handsome fonts of different sizes and styles, and printed in a variety of colours, seemed to jump off the page, acquiring a dimension only hinted at in the original typed manuscript. As the number of completed sets of pages grew, they were moved over to Charles's loft gallery

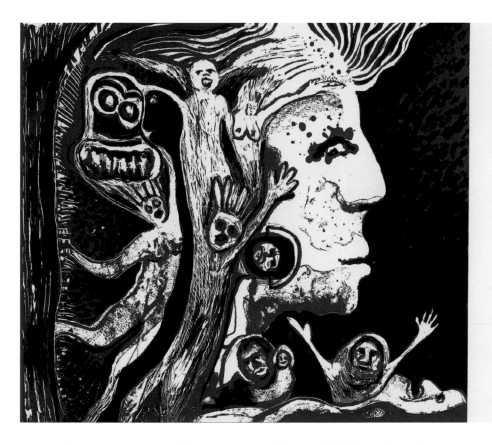

FURTHER ARRIVALS

After we had crossed the long illness
that was the ocean, we sailed up-river

On the first island
the immigrants threw off their clothes
and danced like sandflies

We left behind one by one
the cities rotting with cholera,
one by one our civilized
distinctions

and entered a large darkness.

It was our own
ignorance we entered.

I have not come out yet

My brain gropes nervous
tentacles in the night, sends out
fears hairy as bears,
demands lamps; or waiting

for my shadowy husband, hears
malice in the trees' whispers.

I need wolf's eyes to see
the truth.

I refuse to look in a mirror.

Whether the wilderness is
real or not
depends on who lives there.

"Further Arrivals," from *The Journals of Susanna Moodie*, 1980.

at 553 Queen Street West for sorting, proofing, and folding. Several images were bleed-printed beyond the edges of the paper onto a taped larger under-sheet of paper, then carefully pried free. The edges of some pages were required to be hand ripped to size by an obliging assistant, a girlfriend of one of the two brothers, whom they named Pam the Ripper. All pages required hand folding and scoring before being collated in their proper sequence.

The labour of love was completed in nine months. Charles kept all the completed copies safely stored under the bed of his guest room at 2 Grange Place. The price of a copy was set at $9,000 for the first 20 copies on Canadian handmade paper, $6,000 for each of the remaining one hundred copies on French Arches paper. It was his magnum opus, a crowning achievement, the most elaborate artist's handmade book ever printed in Canada at the time. *The Journals of Susanna Moodie* were first exhibited in November 1980 at his new Loft Gallery on Queen Street West, and again, for the bicentennial of the 1784 immigration of Loyalist refugees into Ontario, at the Art Gallery of Ontario in July 1984.

Beth Miller, professor of art history at the University of Western Ontario, called it "truly the most magnificent book ever to be published in Canada." (*University of Western Ontario Special Collections*, 1980)

Calling it "a triumph," Sara Milroy in the *Toronto Star* on November 1, 1984, wrote that Charles had "a gift for narrative unparalleled in Canadian letters."

In 1980 in *Canadian Forum,* Milroy wrote: "Pachter's collaboration with Atwood represents a Canadian 'moment of being.' When Pachter draws upon his understanding of human personality and his instinct for the historical and the narrative, he truly comes into his own. It is for this reason that the *Journals of Susanna Moodie* has provided such an auspicious outlet for Pachter's gifts and will remain one of his most successful creations."

In the *Virginia Quarterly Review*, Jeff Parker Knight, art professor at the University of Virginia, wrote, "Pachter's silkscreen prints, almost Jungian in their elemental power, complement Atwood's work perfectly, not simply illustrating images from the poems, but finding visual correlatives for their desolate majesty." (April 1, 1998)

Tom Smart, in the Cormorant Books 2014 reprint *The Illustrated Journals of Susanna Moodie,* wrote, "Pachter's pairing of poetry and visual art gave him a fertile terrain in which to develop an exemplary artistic career."

In the foreword to the same edition of *The Illustrated Journals of Susanna Moodie,* art and literary critic David Staines wrote, "Pachter devotes much of his work to an examination of national identity. Seizing upon commonplace objects in the Canadian landscape, the flag, the hockey player, the moose, the northern wilderness, the queen, the Toronto streetcar, he focuses on them with such relentless and varied intensity that he compels us to reconsider these familiar signposts in our collective memory."

Cynthia Nadelman, in *Art News, New York*, wrote, "Pachter's uncompromisingly strong yet sensitive imagery hovers properly between his vision of what Atwood is saying and what the words say on the page. This book is a magnificent example of its kind, to be savored at once and in successive stages."

These responses to *The Journals of Susanna Moodie* were marks of significant recognition for Charles, signs that his career was blossoming.

CHAPTER 13

The Painted Flag

One of the Atwood poems, "Death of a Young Son by Drowning," ends with the line: "I planted him in this country like a flag." Charles has often surmised that this may have led him to a new phase of his painting. In any case, one summer night in 1980, at his farm in Oro-Medonte, he constructed a flimsy, homemade flagpole — out of two-by-fours, hastily nailed together — to which he attached a small rayon Canadian flag that he had purchased at a Canadian Tire store in Orillia. He manoeuvred the unwieldy mast into a fence-post hole, lay down in a hammock to survey his handiwork as the sun set, and watched the flag unfurl, undulating slowly in the breeze, rocking back and forth like a primitive mobile at the top of its slender stem. The effect of wind, light, and motion struck him immediately.

The story behind the adoption of the current Canadian flag is an interesting one. On June 15, 1964, Prime Minister Lester B. Pearson rose in the House of Commons and proposed a new Canadian flag to replace the Red Ensign. The ensuing debate lasted six months and left Canadians bitterly divided. The Canadian public submitted over 3,500 entries for a flag they deemed appropriate. Most of them featured a maple leaf, Union Jack, or fleur-de-lys. Remarkably, 389 Canadians chose a beaver for their flag symbol. After 250 speeches in Parliament on the subject, the government finally invoked closure, and on December 15, 1964, Canada finally had its new maple leaf flag.

In March 1981, Charles began painting variations of the flag at his Grange Place studio, one after the other. Swept along by the possibilities of different compositions based on the effects of wind and light, he could have continued ad infinitum. But

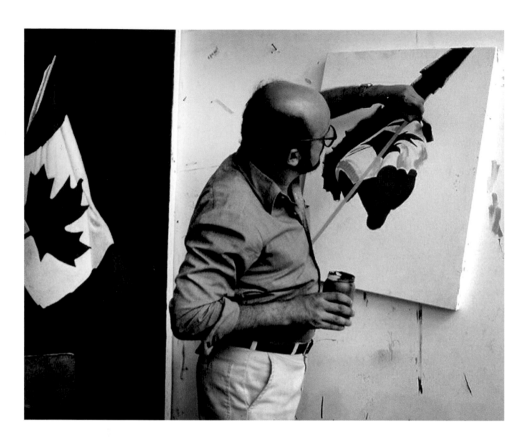

Charles working on a
flag painting, April 1981.

eventually he became "flagged out," and after completing thirty paintings, he began preparing for an exhibition of these new works.

At the same time he was in the midst of renovating a former IGA supermarket on the main floor of a four-storey, twenty-thousand-square-foot building at 567 Queen Street West. It was the most ambitious project he had undertaken to date. With the support of two sympathetic business partners, John Stewart and John Eckler, he transformed the former grocery store into the largest, most glamorous and best-equipped private commercial gallery in Toronto. Rivalling anything in Soho in New York, it boasted a computerized lighting system, sixteen-foot-high walls, and a state-of-the-art storage system.

The *Painted Flag* exhibition opened on November 7, 1981, the day after Prime Minister Pierre Trudeau had coincidentally announced that the constitution was being patriated to Canada.

With *le tout Toronto* in attendance at Charles's opening, from Barbara Frum to Pierre Berton, Peter Gzowski to June Callwood, the champagne flowed. Thirty large

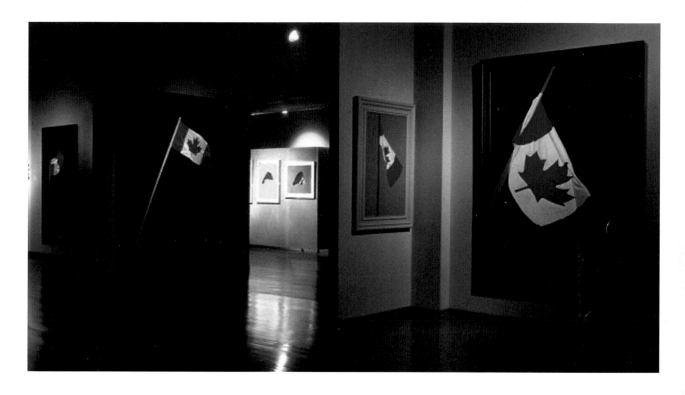

canvases were splendidly mounted and lit in the gleaming new gallery, looking as mystical as a Ming tomb. Queen Street West had come of age, but on the cusp of an imminent major recession, nothing sold. In her November 14, 1981, *Toronto Star* review of the show, Lisa Bowen stated, "there is humour and excitement, colour and texture in this astonishing show."

The Painted Flag Exhibition, 567 Queen Street West, Toronto, November 1981.

John Bentley Mays in the *Globe and Mail* had a different view, labelling it "over-the-couch art for the walls of patriotic dentists."

More than seven years later, Charles was visited by Ian Baines, design official for Canada Post, looking for a design to commemorate the twenty-fifth anniversary of the Canadian flag in 1990. Baines looked at Charles's paintings, bought a set of flag postcards, and promised him $1,000 "if Canada Post approves any of your images." He also asked, "Would you be willing to do a specially commissioned flag painting if Canada Post considered purchasing it?"

"Of course," Charles replied, and immediately wrote Perrin Beatty, the minister responsible for Canada Post, suggesting a flag stamp.

Beatty wrote back that it was a possibility that a commemorative stamp might be considered.

Coincidentally, Charles was introduced to designer Stewart Ash at a party. Ash told him his firm had been hired to design a new flag stamp and that he wanted to consult Charles. He gave him his business card and said that they should get together. As well, Jim Brennan, of the National Postal Museum in Ottawa, bought a set of Charles's flag postcards at his exhibition *Regarding the Flag* at the Ontario Science Centre. He duly passed them on to the Postage Design division of Canada Post.

A few years later, in December 1989, Charles's friend Merike Weiler congratulated him on the newly released Canada Post thirty-nine-cent stamp of the flag, thinking it was based on his design. Charles was surprised and contacted a Canada Post spokesperson, who told him they had consulted with the design firm Gottschalk and Ash and used photos, but not Charles's pictures, to come up with the flag image.

John Laskin, a well-known lawyer and a friend of Charles, now an Ontario Court of Appeal judge, wrote a letter of objection to Canada Post on his behalf. The lawyer for Canada Post informed John that his client's flag paintings were considered, but were neither used nor appropriated. Christopher Hume wrote an article in the *Toronto Star*, called "Whose flag is it anyway?" (1989) exposing the situation to the public. Another lawyer, Aaron Milrad, advised Charles that "suing would be costly and unproductive since the flag was in the public domain, but [he] felt that there was some dishonourable activity involving Canada Post since they had been to see him first and didn't acknowledge borrowing his style."

Stewart Ash phoned Charles and apologized, saying that their creation of a stamp that resembled Charles's version was unintentional. Immediately afterward Charles wrote this ode to Canada Post:

> Whose flag this is I think I know
> Although you added clouds, and so
> As plagiarists you will be cursed
> Since I'm the one who did it first!

In 1990 Heather Reisman and Gerry Schwartz, feeling badly about his flag dust-up with Canada Post, visited him at 2 Grange Place and bought two flag paintings, one to give to the Canadian embassy in Washington, the other for Gerry's Onex office in

New York City. A month later a limo, with Heather and Gerry inside, arrived at his door and whisked the three of them to a hangar at Toronto's Pearson airport, where a small chartered jet was waiting to fly them to Washington. After an elegant lunch at the Canadian embassy, a building that had been designed by Arthur Erickson, Canada's ambassador Derek Burney unveiled the painting with Heather, Gerry, and Charles for a small group of guests. Later the trio flew to New York to hang the other one in the head office of Gerry's company, Onex. Then Charles got on a bus to Newark, flew home on Air Ontario, and abruptly returned to the real world.

Ten years later Jim Brennan, by then retired from the Canadian Postal Museum in Ottawa, visited an autumn exhibition Charles mounted at his Ice House studio on Lake Simcoe. While there Brennan bought more flag postcards and told him emphatically, "Charlie, you got screwed!"

CHAPTER 14

Recession and Comeback

Charles's problems with Canada Post quickly faded into the background, however, when his pal Murray Ball convinced his business partner, Neil Vosburgh, owner of Acme Bar and Grill, just north of King and John Streets, to commission Charles to paint a mural on the restaurant's outside wall. The eighty-foot-long mural depicted the queen patting the snout of a moose, with three block-long red-and-blue stripes emerging from the moose's rear.

Charles was deliberately satirizing *Voice of Fire*, the three-stripe red-and-blue painting by American colour field painter Barnett Newman that was first shown in the American pavilion at Expo 67, and was later purchased by the National Gallery for $1.76 million. Charles called his version *Voice of Culture*.

Arts patron David Mirvish, miffed by this parody, asked him, "How do you expect to be taken seriously when you do work like this?"

Charles told him, "Satire is what Canadians do well."

For the unveiling on a hot August afternoon, a platform was installed in front of the mural. A little girl with wilted flowers sat beside Murray's mother, who was dressed up as the queen's "cousin," Lady Pamela Fitzgibbons Fitzsimmons Fitzhughes. Murray sat beside them wearing a kilt and satin briefs. Charles instructed him to open and close his legs at appropriate intervals for the sake of the media, who had gathered to record the event.

Christopher Hume attacked *Voice of Culture* in the *Toronto Star* as "another flea-bitten gag by Pachter and his moose." (August 1990)

When Gary Michael Dault wrote a review in the *Toronto Star* calling the mural a sad, puerile joke, Dibbles commented to Charles: "Mazel tov, you got hated on an entire page!"

In 1979 and 1980, when he was at the height of his Queen Street West adventures, Charles initiated a restaurant project with the backing of a group of well-meaning investors that would later prove to be his undoing. A large old furniture store at 508-10 Queen Street West with a beautiful but neglected

Left: Charles painting his mural *Voice of Culture* on the wall of Acme Bar and Grill, King and John Streets (where TIFF now stands), 1990.

Below: *Voice of Culture*, August 1990.

nineteeth-century Châteaux-of-the-Loire facade became his new project. After a year of major renovations Charles opened a big glitzy restaurant he named Gracie's (after one of the investors), with four appropriately decorated themed dining rooms. "Just one hour from Mississauga," said Charles in his ads for the restaurant.

"The prime dining space," wrote food critic Howard MacGregor, "is the Forest Hill Room; the one furthest away from the action is the Scarborough Room, while the small enclosed Rosedale Room is elevated so that diners can look down on anyone else in Gracie's."[1] The Rosedale Room's menu included Northrop Fries and Dover Sewell. The signs were interchangeable. The Scarborough Room could become the Downsview Room by turning the sign over. The Scarborough Room had shag broadloom, swag lights, a flickering TV, pole lamps, and gold-veined press-and-place mirror tiles. Its menu included Jell-O mould, shepherd's pie, Rice Krispie squares, and a muddy-looking cocktail called the Don River, made of vodka, beef bouillon, and Worcestershire sauce. Ticked off by how Gracie's was satirizing his borough, the mayor of Scarborough sent

The Scarborough Room and the Mississauga Room, Gracie's Restaurant, 508-10 Queen Street West, 1980. Right, top: Margaret Atwood; right, bottom: Peter Newman.

him a chastising letter, which Charles immediately framed and hung in the Scarborough Room. Gracie's quickly became the gathering place for a growing crowd of filmmakers, painters, writers, TV producers, and loft denizens, mixing it up with business tycoons, socialites, and the curious. Less than two years after it opened, however, Gracie's became the victim of a major recession, serving as few as three people for the evening meal on a cold February night. Charles was forced to put Gracie's out of her misery. In May 1982, he taped a card to the locked front door that read, "Dear friends: We appreciated your interest, but the bank appreciated ours even more."[2]

By late 1981 interest rates had doubled to an unheard of 24 percent. Not only was Gracie's in jeopardy, but many of his Artists Alliance tenants went bankrupt. As mortgage rates rose, real estate values fell. Banks recalled loans. Mortgage companies repossessed properties in default. The economy plunged into a full recession. Charles's roller-coaster existence had come to an end. Forced to sell all the jewels in the Queen Street necklace at distressed prices, he agreed to the bank's demands to liquidate everything in order to keep his house, studio, and sanity.

"I walked along Queen Street like a hobo," he recalls. "For me there was a tremendous feeling of humiliation that I once owned so many buildings that I was forced to sell at a loss."

It didn't help much when Dibbles, doing her best Auntie Mame imitation, told him, "If you went into in the cemetery business, people would stop dying."

Soon came the rummage sales, followed by the inevitable bankers' meetings and lawyers' lunches, where deals were struck and debt repayment plans devised. One by one the buildings were sold. On a winter night, he visited one property to find the front door wide open, the rooms empty. The tenants, unable to pay the rent, had fled overnight. Artists Alliance, the IGA gallery, Gracie's, the Ring Building, the Soho Loft, and the Oro farm were gone. Fourteen properties, fifty tenants, and $2 million in equity disappeared in a matter of months.

After selling off his properties, he was commandeered by the bank to accompany his lawyer to a small windowless room at the office of his bank. There two dour bankers in dark suits confronted them with the opening statement, "You owed us $1.9 million, but you've only paid us $1.8 million."

Charles agreed to their demand to give them a second mortgage on the only property he had left, his own house.

Then they informed him "You're still $140,000 in arrears. We want our interest."

Charles was on the verge of tears. His lawyer sent him out of the room in order to negotiate a deal with the bank. In what may have been an unprecedented move, the

bank accepted art for interest owed. Six of Charles's signature flag paintings are now hanging in their offices. They also took two hundred prints and six *Susanna Moodie* folios. It was finally over. He had lost everything but avoided declaring bankruptcy.

His "ten loft years" had come to an end. The coach houses and bakeries, side alley warehouses, and factories lovingly converted to arts uses, housing painters, publishers, photographers and designers, theatre and dance companies, rehearsal halls, and film studios, were all sold to pay back bank loans. His offices were dismantled, loyal staff let go, paintings stored away, partnerships ended. Confused, dejected, but still intact, Charles came home to the refuge of his studio to confront the emptiness and started to paint again.

His friend, the late George Gilmour, then head of MacLaren Advertising and a past president of the Art Gallery of Ontario, was concerned that Charles might become seriously depressed and often visited him at 2 Grange Place, bringing him meals. George eventually bought one of Charles's best flag paintings for $12,000, declaring that "the price is outrageous, but I must have it." He donated it to MacLaren Advertising, but when the company was bought by Rogers Communications, the painting eventually changed owners and currently hangs in Toronto Mayor John Tory's condo.

Feeling benumbed at the age of forty, Charles vowed to start over. He philosophized that "they couldn't take away my eyes, my hands, my thoughts, and my vision. By losing all that material stuff I got an inkling of the impermanence of things."

As a working artist, he had learned to survive for decades by shopping at Goodwill and eating in Chinatown, and that's what he continued to do. Gradually, he made a comeback. He joined the Arts and Letters Club, sold prints at an art fair at the CNE, and often opened his home and studio to sell work for whatever he could get. He left behind the landlord's world of tenants and staff and offices. Dibbles brought him chicken soup and made sure he came up to the family cottage near Orillia.

During the worst of it, I paid him a visit at 2 Grange Place. When he told me that the bank had put liens on all his properties, leaving him with just his own home, he invited me to come with him to a warehouse he still owned, a few blocks away on Wolseley Street. Asking me not to tell anyone what I was about to see, Charles unlocked the door, turned on the lights, and led me in. Before me was a long room filled with paintings he had hidden away.

Dazzled, I stood there while Charles showed me some of his iconic flag paintings. "Would you like to buy one for $50?" he asked, even though the last one had sold to

George Gilmour for $12,000. I refused to take advantage of him while he was feeling so vulnerable. We lingered a while, then returned to his house for coffee. While there I bought a moose print that I asked him to sign for me.

Charles with Trudie Nelson at an art fair at the CNE, 1982.

"What number would you like?" he asked.

I said "Five."

He signed it 5/500,000.

Before leaving I asked him what his favourite dim sum restaurant was. He told me it was the Imperial on the third floor of 421 Dundas Street West, just around the corner from his house.

A week later I was wandering around downtown and, feeling a bit peckish, I decided to take him up on his suggestion. I climbed the stairs to find the place packed with a long lineup snaking its way in from the entrance. I asked the host how long the wait would be.

He said "At least a half hour. Unless you don't mind sharing a table with someone else."

I didn't mind, and they seated me at a tiny table on the side, opposite an old Chinese lady who spoke no English. I smiled at her; she smiled at me. I ordered my favourite dim sum from the trolleys.

While I was eating, Charles walked in. He spotted me immediately and, without hesitation, cried out, making sure everyone in the restaurant could hear, "Don't worry, Lenny. I won't tell your wife. Your secret is safe with me," turned around and walked out. Next time, I'll consider grabbing a flag painting.

By 1985 things began to turn around. Murray Ball, a long-time friend, asked Charles to do a painting of his dog, Elvis.

"I'll give you $1,500," Murray told him.

Although he needed the money, Charles replied, "I don't do dogs."

Murray responded, "I'll give you $2,000."

Charles stood firm: "I told you, I don't do dogs."

Murray upped his offer: "$3,000!"

Charles said, "Okay, bring him over."

The painting now hangs in Murray's home and apparently Elvis loved it.

When Toronto arts maven Popsy Johnstone asked if he would consider doing a painting of the new west wing of the Toronto Western Hospital as a gift to Fraser M. Fell, the philanthropist who had donated a substantial sum toward the building campaign, Charles said, "Let me think about it.... Yes!" Then he inquired politely, "What's your budget?"

"Five thousand dollars."

"When do you need it by?"

"Thursday."

Charles went over to the site, took some source photos, worked all night, painted a stormy Group of Seven sky for a backdrop and presented it to her a week later.

His biggest break happened in 1983 when his friend Ron Soskolne phoned to tell him he had found a purchaser for some flag paintings. The next night a plain sedan pulled up to 2 Grange Place. Inside was Albert Reichmann, one of the three brothers who ran Olympia and York, one of Canada's pre-eminent property development companies. Charles took him over to the warehouse on Wolseley Street, where he chose three large flag paintings at $12,000 each. Thirty-three years later they still hang in the lobby of the Stock Exchange Tower in First Canadian Place at King and York Streets.

This auspicious placement taught him the importance of having works displayed prominently in public. Charles began to see the whole city as potential show space. He hung seven solo exhibitions around Toronto, finding willing hosts with ample public viewing space, which guaranteed his work would be seen by large numbers of people for extended periods of time: two months at Queens Quay Terminal, four months at

Une Demoiselle de Toronto, acrylic on canvas, 1987. Toronto socialite re-imagined with Picasso face.

(Lady Margaret Hall, Oxford University, U.K.)

the Ontario Science Centre, followed by the Arts and Letters Club, Gallery Moos, the Alliance Française, and Ryerson Polytechnical Institute. Mövenpick Restaurant on York Street invited him to display his paintings for six months.

Another stroke of luck occurred the day Bluma Appel entered his life and became his friend and benefactor. She and her husband Bram had started out modestly in Montreal, she working as a social worker, he as an accountant. He made his fortune

Charles with Bluma Appel at his exhibition in Montreal, 1988.

through some smart investments and the family was doing very well in Montreal. However, they decided to move to Toronto in 1976 following the Parti Québécois win. In their new home, the couple, together with their sons, David and Mark, worked hard to help improve things for their fellow citizens, becoming major cultural philanthropists in Toronto.

When Bluma first met Charles and saw his work, she told him, "You're way ahead of the rest of the pack. You have the ability to light up a room. You're like champagne — you're bubbly and you make people feel good." She told him that "PhD scholars will be doing theses on your work many years after you're gone. Forget the mean-spirited art critics who hit on you. Newspaper reviews are soon forgotten. So are critics."

The reason he hadn't been extolled by the art establishment, she felt, was that he was considered "too funny, mischievous, and entrepreneurial," echoing Atwood's view that he was, "too mouthy and witty when most Canadian artists are modest and self-effacing."

Art critic Lisa Balfour Bowen agreed, stating that "the art establishment resents your articulate nature and your refusal to sell through the galleries. They feel you're a smartass who refuses to do the highbrow intellectual art that the highfalutin' critics and curators love."

Not a great fan of the conceptual piles of stuff often seen on the floors of public museums, Pachter has always felt that art should communicate, that there should be an intimate interaction between the work and the viewer.

Bluma not only complimented him, but also purchased his art, advocated for him to all her well-connected friends and associates, and attended his openings. Soon after she returned from his exhibition in St-Rémy, France, Bluma invited him for dinner at her sumptuous, art-filled two-storey condo in Hazelton Lanes. There she showed him "My three Ps — Picasso, Pissarro, and Pachter!"

When Mayor Art Eggleton offered Bluma the opportunity to name a Toronto theatre in return for a donation, the Bluma Appel Theatre was born. She often invited Charles to watch plays with her in her private box. Often, when he would groggily answer the phone at 6 a.m., it was Bluma, asking "What are you doing up so early?" She would invite herself over to his house, knock on his door with curlers in her hair, head straight to his couch, lie down, and do what she loved to do most — talk.

During a visit to the Ice House, his cottage studio on Lake Simcoe, she told him, "Your love for Canada is so deep. You're a visual Mordecai Richler, full of visual puns and mischief."

The mid-eighties saw Charles back in full swing, producing new work and participating in international shows. In 1984 Charles was invited to be part of a group exhibition called *Vestiges of Empire* at the Camden Arts Centre in London, England, where *Queen on Moose* made its British debut. A poster of the duo presented to Buckingham Palace was received with gracious aplomb by Sir Philip More, Head of the Household, who commented, "Actually, it's rather a good likeness."

"Of whom?" Charles asked

"Of them both!" he replied.

Along with royalty, Canada's colonial past continued to engage Charles's imagination. Charles chanced upon a biography of John Graves Simcoe by William Renwick Riddell in a bookstore in Niagara-on-the-Lake. In Hugh Hood's bookstore in Toronto's

Simcoe's Illusion, acrylic on canvas, 1991.

west end, he found Ernest Cruikshank's landmark volumes of Simcoe's correspondence, written while he was busy settling Upper Canada as its first Lieutenant-Governor. All of this material kindled Charles's interest in the early history of British North America, and helped in his quest to identify the origins of the modern Canadian mindset.

John Graves Simcoe, a British career soldier, had fought for seven years in the American Revolutionary war, returned to England a defeated officer, and became a member of parliament. He lobbied Prime Minister William Pitt to be appointed Lieutenant-Governor of the new colony, founded on land conquered just thirty years earlier when Britain's General Wolfe defeated France's Marquis de Montcalm.

Simcoe married eighteen-year-old heiress Elizabeth Posthuma Gwillim, they raised a young family, and they came to what is now Ontario to create the new British colony of Upper Canada. More than fifty thousand United Empire Loyalists, the name given to them by Lord Dorchester, left the Thirteen Colonies of the United States to settle as refugees in present-day Ontario and Quebec. Simcoe's choice for the capital was London, Ontario, but his superior, Lord Dorchester, governing out of Quebec City, preferred the site of York, now Toronto, which Simcoe founded. Lieutenant-Governor Simcoe planned and built Yonge Street, and named Lake Simcoe after his father, who died of pneumonia and was buried at sea off Anticosti Island en route to Quebec with General Wolfe in May 1759.

Simcoe died in 1806 at age fifty-four, on his way to India to replace Lord Cornwallis as Governor. Simcoe made such an impression that Charles spent the next few years painting portraits of him, his wife Elizabeth, and his soldiers, the Queen's Rangers. Inspired also by Roald Nasgaard's AGO exhibition, *The Mystic North*, a survey of European influences on the Group of Seven, Charles started a new series of paintings in which he appropriated the expressive brush techniques common to the Group of Seven. Into this context he injected local historical events and visual puns. *Cold Comfort* reimagines the arrival of a Loyalist soldier on the windy shore of Lake Ontario. The Loyalists were determined to continue their lives in a newly created British colony north of the new American republic. It is obvious that Charles identified with Simcoe, who he continues to believe was an enthusiastic nation-builder deserving of more recognition.

While Canada's history was an important source of inspiration for Charles, he maintained a strong interest in contemporary Canadian culture and its symbols. In 1985 Charles created two murals, *Hockey Knights in Canada* and *Les Rois de l'Arène* for Toronto's College Street subway station near Maple Leaf Gardens, and supervised their installation. Leafs owner Harold Ballard was furious that he placed the Leafs and the Canadiens across from each other, but his fulminating caused the media to cover

Cold Comfort, acrylic on canvas, 1983.

(Private Collection, Toronto.)

the unveiling and as a result the public learned more about the artist. At the official unveiling, in the presence of hockey stars and other VIPs, Dibbles was asked by a reporter what she thought of the murals, prompting another of her famous one-liners, "Well, it's the basement, but it's permanent."

Another work showcasing a classic aspect of Canadian culture was inspired by a visit Charles made to his farm one spring weekend. During the visit he noticed that the field in front of the barn was flooded from the melting snow and had become a temporary lake. The reflection lasted about a week, but he was glad to witness and record it. Six years later, back in his Grange Place studio, he began experimenting on his new Commodore Amiga computer, flipping the image of the red barn he had

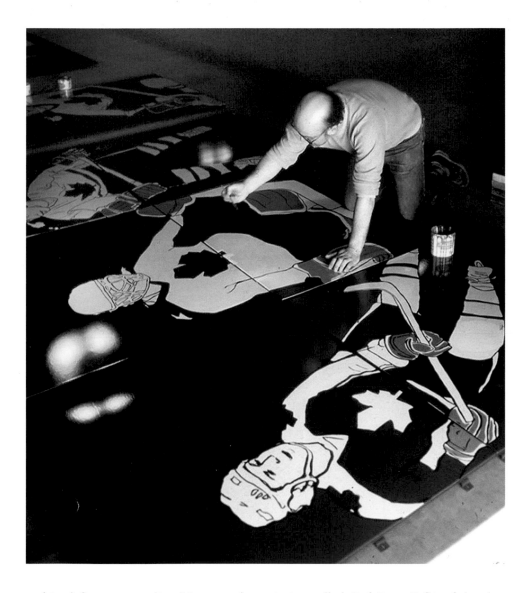

Charles working on his mural for the College subway station, 1984.

archived five years earlier. He created a painting called *Red Barn Reflected* that has become one of his best-loved images.

Charles was definitely on the comeback trail.

In 1988, Moses Znaimer, media guru and head of CITY-TV, commissioned him to paint a dual portrait of him and his partner Marilyn Lightstone. Moses also bought a flag painting, a *Queen on Moose* serigraph, and the large painting, *Figures in a*

Red Barn Reflected,
acrylic on canvas, 1987.

Facing: *Float*, serigraph,
1986.

Landscape, inspired by summer picnics at his farm, depicting Moses Znaimer, Toller Cranston, Ruby Bronsten, Venable Herndon, Lynn King, and Marci Lipman seated in two groups of three. It was purchased by Sir Christopher Ondaatje who donated it to a National Ballet fundraiser, where it was subsequently purchased by Znaimer.

In 1985 during a visit to the National Museum in Tokyo, Charles was awed by the visual purity of the design he observed in tenth-century Japanese tapestries and screens. He wondered if he could have been Japanese in another life, since he had spent decades in the studio trying to reduce an idea to its simplest form. Clarity and simplicity were his mantras. He left the museum feeling breathless.

Back in his Toronto studio he re-examined a painting titled *Float* in which he had depicted an outboard motor boat at the end of a dock. A horizon line in the distance anchored the objects to a finite reference point. On returning from Japan, he removed the horizon line. The air and water were absorbed into one atmosphere. The boat and dock were released from gravity to hover in space.

A similarly reductionist painting depicts six Canadian Supreme Court judges; he titled this work *The Supremes*. In the streets of Tokyo, Charles had seen priests wearing vestments and women in kimonos, leading him to think about Canadian counterparts. The result was *The Supremes*, a group picture of Canadian Supreme Court judges wearing red smocks with white fur trim appropriated from British counterparts.

The trip also caused him to reconsider a tent form he had been exploring in several paintings. It was based on Mrs. Simcoe's diary description of the "Canvas House," a large tent the Simcoes bought from the estate of Captain James Cook to house them in the wilderness at York. When Charles thought about the tent in which Simcoe and his family resided while living in Upper Canada, he recalled the simplicity and beauty of the art he saw in Japan. The triangle of the tent became an icon that resonated with him, and became an image he repeated in *To All in Tents* (*En Tente Cordiale*) and numerous other paintings.

Many of Charles's works have similarly clever titles. For example, Charles painted a still life of butter tarts, his favourite dessert, and as he has often noted, Canada's gift to the pastry world. He called it *State of the Tarts*. Mrs. Wilkie, of Wilkie's bakery in Orillia, came to see the painting in his

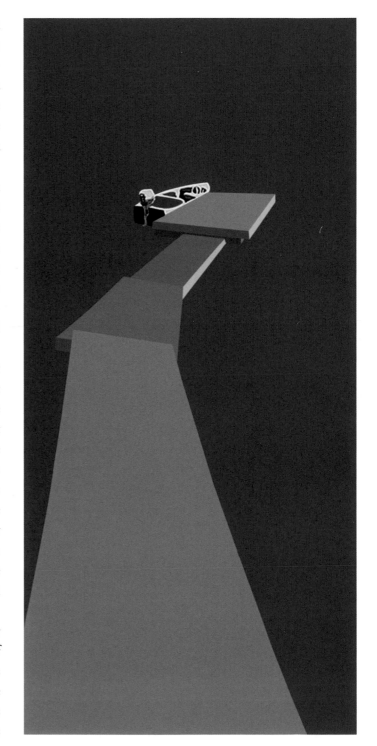

The Supremes, acrylic and pastel on canvas, 1987.

(Bora Laskin Law Library, University of Toronto.)

exhibition at the Orillia Museum. When she saw the price of $30,000, she exclaimed, "Thirty thousand dollars! The bakery isn't worth that!" When Charles suggested he give her a print to hang up in the bakery, she asked, "What'll you be wanting in return for that then, eh?"

"How about butter tarts for life?" he asked.

She replied: "We'll start with a dozen."

Gradually Charles began to resume what was for him a more normal existence. He had lost the Queen Street empire, but he had never lost his belief in himself or in his talent. He was back in the studio, doing what he loved, painting, sleeping better, spending more time alone. He was entering a more stable period, and the world was starting to look a little brighter.

CHAPTER 15

The Baron of Beverley

Charles's routine was now pretty well established. At times he missed the problem-solving and responsibilities of the old real estate empire, but he came to accept the solitude and walking into the studio without leaving home. Often, days would go by without him seeing anyone. He found himself grazing in between painting instead of sitting down to a meal, and would usually eat standing up in front of an unfinished work. On good days he felt this routine was a privilege; on bad days it was a trap. Up in the morning, coffee, into the studio. Paint. Clean up. Graze. Nap. Reconsider the painting. Revise. Destroy. Repaint. Graze. But when he did a good piece of work, he felt the elation and danced a quiet jig. He was usually in the studio working on three or four pieces at a time. Still, the isolation could be disconcerting.

One day, Fanny called to tell Charles about an old apartment building on Beverley Street that she thought he should see.

"Not interested," he said, "I'm painting."

"But it's just across the lane from your studio, and it looks out on Grange Park." She continued dangling the bait. "It's a mess. It needs everything done to it. Nobody could redo it like you. And you're right next door …"

Charles went with her for a look-see and was hooked. Three years after vowing never to touch another old building, he jumped back in, bought this wreck, and began the task of transforming it into six elegant apartments, with floor-to-ceiling windows overlooking historic Grange Park.

Tenants, neighbourhood committees, historical societies, building inspectors, politicians, and activists all had a go at him. He had forgotten about the day-to-day

Fanny Silberman and Margaret Atwood, 1980.

trivia, the paperwork, the bureaucratic obstacles, the delays, the opposition, the cost overruns, the financial stress, the frustration with tradesmen, the disappointments, the compromises.

As the project neared completion, and the newly designed, painstakingly rebuilt Beverley Arms welcomed its first occupants, Eti Bareket, Bill House, Julia Watt, Madeleine Thompson, Scott James, Sheldon Rosen, and Blake Jones, Charles began to think it was worth it. As Fanny put it, "You're no longer the King of Qveen, now you're the Baron of Beverley!"

He convinced his friend Eti Bareket to be property manager for the various suites, some of them named to honour singers Anne Murray, Carole Pope, and Maureen Forrester. Once the place got settled, he started hosting summer solstice parties in the lane between 80 Beverley and his studio at 2 Grange Place. In 1988 he dubbed the first event Summit Up, since the AGO was being used as a G8 Summit venue. Three hundred guests were invited, but nine hundred showed up. A Margaret Thatcher look-alike rode down the lane on a bicycle as hot dogs and beer were served by "Charlie's Angels," the beer kept cool in an ice-cube-filled canoe in the parking lot behind 80 Beverley. Plastic fruit decorated the huge cherry tree in the garden of 80 Beverley, a tiny Canadian flag was hung from a thirty-foot spindly flagpole and Dibbles guarded the party sandwiches that were laid out on trays.

"Were you invited?" she asked the guests as she slapped the hands of hungry artist friends and party crashers. "You've had seven, that's enough. Leave some for someone else. This isn't the Salvation Army."

Shortly after Summit Up, Charles was invited by Toronto showbiz impresario Gino Empry to install a solo exhibition in La Citadelle, a new boutique hotel beside the Place des Arts in Montreal. After the opening Charles met Pierre Trudeau at a dinner party in Montreal hosted by Trudeau's friend and neighbour Nancy Southam. Dressed casually in an open shirt and corduroy jacket, Trudeau was engaged in a heated discussion about the Meech Lake Accord with eight other guests, including philanthropist Phyllis Lambert and architect Arthur Erickson.

Charles, having sipped one too many glasses of good wine, blurted out, "Enough with Meech Lake. I have a more important question. Where is my flag painting?"

Charles was referring to one of his flag paintings given to Trudeau by Jim Coutts and Keith Davey on his retirement in 1984. The conversation stopped.

"Would you like to see it?" asked Trudeau.

"Sure!" said Charles.

"Then come with me," Trudeau said.

Trudeau got up from the table and walked Charles over to his home, an art deco mansion a block away.

Once they were inside, much to Trudeau's delight, Charles was able to describe the provenance of most of the tapestries and furniture there. When they reached the den, where Charles's flag painting was hanging over the fireplace, Trudeau said, "I hope you realize how much this painting means to me."

Charles said, "*C'est un ange qui passe.*" (An angel is passing overhead.)

They continued to talk for a while and then eventually returned to the party.

Upon their return, Arthur Erickson asked him, "So how was it?"

Charles smiled and replied, "Pierre just showed me his bedroom!"

Charles's encounter with Trudeau was a highlight of the year. It was a year, however, that saw a significant loss for Charles.

One such loss involved one of his tenants at 80 Beverley, Herb Denton, a man Charles had met through Nancy Kroeker, Denton's former executive assistant. Herb was the forty-year-old Toronto bureau chief for the *Washington Post*. He had won the Purple Cross for his service in Vietnam. He used to tell people he knew he was in a different country when, at the Empire Club, a big black guy with medals walked in, and everyone stood up, saying "To the queen." The guy was Lincoln Alexander, Ontario's lieutenant-governor. Denton became Charles's buddy, attended his parties, and wrote him a kind letter when he turned fifty. Denton was scholarly and gay, with a Canadian musician as his partner.

When Nancy had not heard from her boss for a few weeks, she phoned Charles to ask if he knew where Herb was. Since Charles had a key, he entered Herb's apartment and searched around until he found him curled up on the bedroom floor, his body covered in sores. Shocked, Charles drove him to Toronto Western Hospital, where he learned that Herb was dying from AIDS.

Charles called Herb's mother in Arkansas and his brother in Houston, by which time Herb was on life support. They flew to Toronto and came to see him immediately. A few days went by. The doctor's prognosis was that he was fatally ill. Asked if he wanted to be taken off life support, Herb, unable to talk, wrote a note saying, "Not yet." Two days later, a second note simply said, "Slip quietly into the night without pain." Heavily sedated, he died without pain at 8:45 p.m., Saturday April 29, 1989. In his memory, a tree was later planted in Grange Park by his neighbours at 80 Beverley.

Another even bigger loss occurred when Charles's father died. Har was a gentle, kind, somewhat passive individual, who enjoyed letting his wife be the star. Once Charles took his father to see a matinee performance of *La Bohème*. When Har had had cataract surgery, the surgeon accidentally cut the optic nerve, leaving Har blind in one eye. Charles visited him in his office the next day and found him sitting there alone among his mementos — blotters, old faded photos — with some of Charles's early prints on the walls. After some small talk, Har led the conversation around to their family and issues of loneliness, admitting it was tough for him when Dibbles was away leading her tours to Israel. Charles told him it was often tough for him as well. Har asked Charles if he ever considered having a live-in companion. Soon they got around to discussing his sexuality.

Har said, "I only hope that you find whatever it is that you want."

"My work has always taken precedence over my personal needs. Living with someone," he told his father, "is something I have continued to avoid."

Charles saw Har again on October 30, 1998, the day before he died. Har had always collected and told jokes at family functions, meals, and Seders, and Charles usually remembered them. As he lay peacefully in bed, Charles asked him, "Har, what was that joke again about the waiter and the specials?"

His eyelids fluttered open. Slowly he emerged from his stupor, looked at Charles and said softly, "The customer asks the waiter, 'What are the specials?'

"The waiter, picking his nose, says 'macaroni and cheese,' then scratches his bum and says, 'and shepherd's pie.'

"The customer asks, 'Do you have hemorrhoids?'

"The waiter replies, 'No substitutions!'"

Those were the last words he heard his father utter.

CHAPTER 16

L'Artiste et la France

Bogomila Welsh-Ovcharov was Charles's friend and fellow student from the U of T Fine Arts program in the 1960s. In March 1991, now an eminent art historian, she invited him to France to meet Philippe Latourelle, the curator of the Musée d'Art Présence Van Gogh in Saint-Rémy-de-Provence, a town where Van Gogh had spent time as a self-admitted patient at the Saint-Paul asylum from May 1889 to May 1890. Latourelle agreed to give Charles a show in a home that once belonged to the Grimaldis of Monaco — a heritage site that had been beautifully restored to house a museum for contemporary art in the heart of this historic town in the south of France. The exhibition took a year to organize, with key works borrowed from many collectors. It was officially opened by the French assistant minister of culture, Catherine Tasca, whom Charles had met in Toronto a year earlier. Thirty of his friends and sponsors flew to France for the opening of the show and stayed on for an extended tour of the Midi, the South of France.

Over forty paintings, including *The Supremes* and *Davenport and Bay*, were exhibited in eight galleries on three floors. This was a milestone in Charles's thirty-year career. In St-Rémy, he noticed that the French treated artists the way Canadians treated hockey players, calling him *"le maître d'exotisme Canadien."* The show later moved on to the Haus an der Redoute in Bonn, Germany.

The *Globe and Mail* critic, John Bentley Mays, derided Charles and the show, suggesting that his rich collectors had bought the gallery. In fact, the money that was raised paid for shipping, crating, and insurance for the paintings. In an angry letter to the *Globe*, Bluma Appel called it a personal vendetta against Charles. Beloved by

CENTRE d'ART
PRÉSENCE VAN GOGH
EXPOSITION
CHARLES PACHTER
Tous les jours de
de 10h à 12h
et 14h à 18h
Fermé le Lundi
Entrée 20 f

Charles at the opening of his exhibition at the Centre d'Art Présence Van Gogh in St-Rémy-de-Provence, October 1991.

the media and the public for his sense of humour and mischief, the *enfant terrible* was dismissed yet again by art critics who refused to take him seriously.

Robert Welsh, professor and Mondrian scholar at U of T, and the husband of Charles's former classmate Bogomila Ovcharov, suggested to his wife that she write a monograph on Charles and his work. Charles discussed various options

with Avie Bennett, head of McClelland and Stewart at the time. Chief editor Doug Gibson gave the project the go-ahead. Bogomila took a year to research and write it, and the deluxe art book was published in October 1992 in an edition of 3,500 copies.

A zany and colourful book launch was dreamed up by Charles's friend Murray Ball, who was running a huge nightclub on Queen's Quay called RPM. Show business impresario Gino Empry found two drag queens to appear as Queen Elizabeth and Princess Diana. Christopher Hume, reporting in the *Star* that over three thousand people turned out, couldn't believe that Charles knew so many people and wondered how he managed to go home alone afterward.

It was more a show than a launch, and Charles was on stage doing his best CBC anchorman commentary in a deadpan monotone. "We have just heard," he intoned, "that Her Majesty has landed at Pearson and is making her way down to our launch." A few minutes later, he told the audience, "Her Majesty has arrived. Will you all please rise for Her Majesty the Queen." As the spotlight hit the "royals," arriving and waving, the crowd applauded and giggled. "Doesn't she look radiant in her mauve peau de soie dress with matching gloves!" Charles continued. Everyone enjoyed the charade and played along with it. When the duo finally made it to the stage, Charles welcomed them as everyone curtsied and waved. Ontario Lieutenant-Governor Hal Jackman, seated on stage with Margaret Atwood, Avie Bennett, and Ed Borins, was trying to look "official" as "Princess Di" grabbed the mike to ask, "Didn't Mommie Dearest look lovely on the moose?"

The "queen" pushed her aside and said, "I was told not to comment." He was an accountant from Bradford who had taken three hours getting into his makeup, gloves, tiara, and gown.

Neil Vosburgh, owner of the Duncan Street Grill, provided the food, Donald Ziraldo provided the Inniskillin wines, and bookseller Edward Borins arranged eight tables with one hundred copies of the book on each. Priced at $90 each, only seventy copies were sold.

In the *Globe and Mail*, art critic John Bentley Mays attacked the book, saying that Bogomila was foolish to compare Charles to Chagall. Charles, about to turn fifty, was beginning to feel depressed. Graeme Gibson called to say, "Do you know how many reviews I have received like that? The book will outlast the reviewers and Mays."

In an attempt to cheer him up, Peggy wrote the following ode:

Oh what is the matter with Bentley
He hasn't a cough or a pain
Most everyone's treated him gently
Yet he's trashed Charlie Pachter again.
When it comes to religion, why not a soul
Would venture where angels don't trod
Yet Bentley says Charlie ain't got a soul
So who's he to judge, if not God.
Is it true Charlie can't keep his yapper tame
Said old Bentley, was hard to construe
And by Zena, nee Cherry, that dapper dame
He'd much rather have a review.
Old Bentley's been seen since, or so goes the rumour
Flounces all over Pachter in such an ill humour
Or perchance 'twas his parents that made him so blue
If your name was Bentley, bet you'd be sore too.[1]

David MacLean, of the *Vancouver Sun*, took a more positive approach, writing, "Ironical work that is both serious and self-parodying, Pachter works hard, even at the trivial. The paintings are beautiful in one way or another, like joke panels that take your breath away. These witty, occasionally dry images are more than urban jokes; they have emotional staying power. Pachter invades pop culture with surreal wit. He sometimes paints as an insider to culture and at others like a true outcast. His work escapes a tendency toward intellectualism through the sheer power of talent and love of image." (January 2, 1993)

Two months after his book launch, Charles turned fifty on December 30, 1992. At a dinner with friends at the Avocado Club restaurant at Queen and John Streets, he felt alone in the darkened room, noticing that everyone was talking to each other, but no one was talking to him. Their lips were moving, but he heard nothing. Charles Pachter was depressed. A psychiatrist recommended by his friend Rosie Abella prescribed Prozac for him, but after one week he threw the pills away, hoping for an alternative way to confront this mid-life crisis.

CHAPTER 17

Miami Beach Chronicles

While visiting his parents in West Palm Beach in March 1993, Charles phoned his old friend Barry Zaid, asking Barry to rescue him from watching his parents eat the early-bird special at 5 p.m. at the International House of Pancakes.

"Charles," Zaid told him, "come to Miami Beach. It's gorgeous here."

Prozac or Miami? Charles chose Miami.

Barry, a well-known graphic illustrator originally from Toronto, had moved to Miami Beach after years in New York and was living in a charming art deco condo in South Beach, at Meridian and 30th. Charles discovered a Miami Beach that was filled "with young, gorgeous men from Brazil, England, and Germany, most wearing Speedos and lathered in suntan oil, sitting at the beach picking at blackheads on each other's backs, and indulging in foam parties at night in the clubs." He felt like he was in a Fellini movie.

While he didn't participate in the action, Charles stayed for a week at Barry's place, met a realtor named Kitty Roedel, and ended up buying a house, a pink 1940s art deco villa, with marble floors and a dirt backyard surrounded by chicken wire, located at 3003 Sheridan Avenue, a few blocks north of the Delano Hotel. Charles furnished it with "Art Drecko" castoffs. A six-piece sectional made of vinyl and rattan cost him $100 at a hospital thrift shop, two glass and metal coffee tables were $2 each, and a wooden armchair found at a local lawn sale went for $5. Barry Zaid later saw a coffee table just like the one he purchased for $2 at an antique store for $500.

"You scored," Barry told him. During a later visit, Dibbles scolded him, "You have a great eye. Don't tell everyone what you paid!"

Charles paints a *trompe l'oeil* pool in the garden of his home in Miami Beach, 1995.

Charles joined a Miami gay mens' therapy group that Barry belonged to, but after six meetings, Alina the therapist told him, "You're too smart for this group. You're too glib and not being honest."

He was no longer welcome.

Charles said, "I saw myself as an ugly fifty-year-old. I felt sad in January sitting alone in my tropical garden even though I was surrounded by birds and flowers."

Nevertheless there was a steady stream of house guests and parties for the next six winters. Charles made a sign that read "Anyone who buys a painting gets three nights free, fresh sheets, and the alcoholic drink of his or her choice. Anyone who buys a print gets one night free, sheets questionable. Anyone who just buys a postcard gets to wave from the car."

Among his many visitors was his old friend, author-journalist John Lownsbrough. Since everyone in Florida had a pool, John went into Charles's backyard looking for one. What he found was a *trompe l'oeil* pool that Charles had painted onto the concrete patio in his yard, complete with faux painted turquoise pool and faux tiles, and two signs, one saying, "No Diving" and the other, "Shallow End."

"Less maintenance," Charles told John.

On a shopping trip to the local Publix grocery store to buy food for one of his parties, a tall, black male cashier asked him, "How ya doin', honey?" Moments later Charles invited him to his party that night, where he ended up mingling with socialites Malka Green, Bluma Appel, and Carole Grafstein, and celebrities like Edward Albee and Arthur Erickson. Charles spent the rest of the week taking his guests to see flocks of gay men frolicking on the beach — old, young, ugly, gorgeous, hot, cold, hairy, and smooth.

He also showed them another side to Miami, driving them through the wasteland of Hialeah, past car wrecks and crumbling houses, stopping at vast indoor flea markets

full of booths manned by Asians and Hispanics selling old clothes and cheap stereos to blacks dressed in outlandish clothes. Charles drove them through decrepit slums where they saw cop cars surrounding a beer store, homeless bag people camped under expressway ramps, boarded-up buildings.

"So many lost souls in Miami Beach," Charles observed.

He pondered why he had come to Miami in the first place. Was it to deal with personal issues? To feel comfortable as a gay man? To face his fear of being alone when he got ill? Whenever he got anxious or depressed, he'd tell himself, breathe, hum, read, listen, think, reflect, see, observe, record, hope. He often asked himself, *How do I reconcile my need for solitude with my natural gregariousness? Why do I believe that I function better alone? And what about the deep void caused by uncomprehending parents?*

Without a TV and with warm sunny weather almost every day in Miami Beach, he confronted his demons, learned to live with SAD (Seasonal Affective Disorder) — mild depression caused by early darkness in the winter months — and turned out some of his best and most colourful paintings. *Apex* and *Over the Waves* both depict

A Delicate Balance, acrylic on canvas, 1994.

(Private Collection, Toronto.)

Halfway Up Halfway Down, acrylic on canvas, 1995.

(Private Collection, Toronto.)

men lying in beach chairs; *A Delicate Balance* juxtaposes an elderly lady sunning on the beach with two gay men lying at her feet; *Odalisque* shows a nude woman on the beach; *Duet,* a gay man posing with his white poodle; and *Halfway Up Halfway Down,* a yellow 1950s convertible — a painting that is now in the collection of Madam Justice Rosalie Abella.

From 1993 to 1999 Charles would pack up his old Reliant station wagon with clothes and art supplies, and drive the 1,500 miles, most of the time alone, to Miami Beach, returning to Toronto every April. This routine continued for six years until he recognized that he was coming to the end of a life cycle and felt it was time to sell the house and return to Canada.

CHAPTER 18

The Moose Factory

Charles's home and studio at 2 Grange Place was directly behind the Toronto Chinese Baptist Church on Beverley where, on Sunday mornings, in warm weather, he could hear the strains of the hymn "Glory, Glory Hallelujah" (with questionable pronunciation!) wafting across the lane from the church's open windows. More than ever a microcosm of Toronto's multicultural population, the Grange neighbourhood has been home to immigrants for over two hundred years.

One day Charles was walking up Grange Place toward Dundas to do some grocery shopping, when he noticed a FOR SALE sign tacked to the front of an old Insulbrick garage on the north side of Grange Avenue, a few houses west of Grange Place. He phoned Fanny and asked her to check it out.

She quickly phoned back saying, "You von't believe it, there's a varehouse in the back."

"A varehouse?" he asked, "All I see is a garage."

Fanny responded, "I already made an appointment."

After twenty-six years at 2 Grange Place, having run out of space to work and store his paintings, and having lost the Queen Street properties, Charles was curious to see this new place around the corner. There was no access from Grange Avenue, so they came around to the back door via the rear lane. Inside, it was a disaster. The roof had fallen in, and there were shoulder-high stacks of junk — boxes, rusted tins of soy sauce, rats scampering out of bags of rice. But this rear warehouse extended west for forty feet behind the neighbouring property, with 2,400 square feet of usable space. Once again, Charles was hooked.

Houses on the street were selling for around $150,000. The asking price for this wreck was an absurd $389,000. Fanny immediately started sparring with the owner, gesturing to Charles to keep quiet. Then she went into her aggressive routine.

"Mr. Lee, this is junk. Feh! Pooey!" she yelled, feigning a spitting motion.

Mr. Lee replied, "No, dis Chinatown, heart of city, velly valuable!"

Fanny retorted, "Mr. Lee, you didn't get any offers. This is a mess! You should be ashamed!" Then Fanny whispered to Charles, "He's asking 389, so we'll go in at 140."

Charles said, "Fanny, he won't even look at it."

She told him to go home. A half hour later, somewhat fatigued, she came back to Charles's at 2 Grange Place. "You von't believe it," she said, "vee got a sign-back."

"You're kidding."

"Take a look."

Mr. Lee had crossed out $389,000 and signed it back at $385,000.

"Never mind," said Fanny. "Dat's progress."

Charles remained hopeful.

Four months passed. Fanny phoned him, hyperventilating. "You von't believe it. He vent bankrupt. We're going back in at $145,000."

Charles Pachter bought 22 Grange Ave for $145,000.

Fanny said, "Okay, you had your Holocaust. Now you gonna rise from the ashes. You were the King of Qveen, now you'll be the Guru of the Grange!"

First he tore down the Insulbrick garage in front and created a parking area. Then he set to work gutting and reshaping the old Chinese food warehouse at the rear of the property. He later found out that it was originally built as a Jewish funeral home around 1900 in what was then known as the Ward, an area home to immigrant families from all over, and especially Eastern European Jews. For the next few years he commuted back and forth between his home, a block away at 2 Grange Place, and his newly created gallery and live-work space at 22 Grange Avenue. He named it Moose Factory, a play on words based on the Hudson Bay Company's famed eighteenth-century outpost in Canada's far north and his ongoing depiction of the iconic moose.

Charles's fascination with moose expressed itself elsewhere, too. In 2002 Charles donated a corten steel moose sculpture to the University of Toronto, where the positive silhouette cutout *Mooseconstrue* was installed on a grassy mound at the southwest corner of Harbord and St. George Streets. As well, two negative cutout panels *Moosedemeanour* were installed in the interior courtyard pond of the newly built Graduate House at Harbord and Spadina.

Mooseconstrue, corten steel, 1999.

Charles met the architect of Graduate House, Stephen Teeple, at the unveiling of his moose sculptures. He mentioned to him that he was considering building a new home on the front parking lot that would connect to the existing Moose Factory and asked Stephen if he would like to come up with a concept. Steve created a striking model of three stacked "shoeboxes," a glass and steel structure that fit snugly into the existing streetscape. Delighted with the result, Charles named it Pachter Hall. The plans were submitted to Committee of Adjustment at City Hall in March 2003. Not one neighbour came to object. The project was approved.

Construction began in April 2004. Meanwhile Charles sold 2 Grange Place and moved into the Moose Factory temporarily, to watch over the construction of the new house and to suggest changes he thought necessary along the way, like resizing a window here, moving a staircase there. The completed new house opened to much buzz, and subsequently received the Ontario Association of Architects Award of Excellence, the Plachta Award, and the Design Exchange Award. The juxtaposition of his contemporary glass and steel box between two tatty old houses is quite remarkable.

Charles's diary entry of November 16, 2005, mentions some of the guests who attended the opening of Pachter Hall and Moose Factory at 22 Grange Avenue: Marq de Villiers, Michael and Honor de Pencier, Marjorie Harris and Jack Batten, Margaret

Pachter Hall rises in front of Moose Factory, 2005.

Atwood and Graeme Gibson, Conrad Black and Barbara Amiel, Anne Libby and Allan Fotheringham, Eddie Goodman, Kevin and Marion Doyle, Minette Ross, Robert Ramsay and Jean Marmoreo, June Callwood and Trent Frayne, Elizabeth and Jack McClelland, Roy and Ria McMurtry, Rosie and Irving Abella, Isabel and John Bassett, Robert Fulford and Geraldine Sherman, Edward and Eva Borins, Beverley Slopen, Sylvia Fraser, Catherine and Julian Porter, Malcolm Lester, Norman Jewison, Murray Frum, Martin Knelman and Bernadette Sulgit, Allan and Sondra Gotlieb, and Patsy Aldana. When Dibbles was asked by the media at the opening party what she thought of the new Pachter Hall, she uttered another of her great one-liners: "Fifty years it took us to get out of this neighbourhood, and he turns around and moves back in."

Next door to Pachter Hall is a shabby old house at 24 Grange Avenue that houses a Chinese poker and mah-jong club, where a gaggle of older gents enjoys sitting on the porch playing cards and schmoozing, oblivious for the most part to the guests visiting Charles's gallery and studio. Their front yard is a funky mishmash of trash cans, bicycles, assorted bits of junk, and boxes of plastic flowers. When Charles showed them the designs for his new house, the club's president looked at the mock-up thoughtfully, and then with a big grin remarked, "You smart guy, Yuppie Renovator. Make everybody property more valuable!"

Having seen so many elegantly dressed ladies coming in and out for various openings, the club president leaned across the fence one day, and giggling, asked Charles. "What you do here? You bring lady at night?"

Charles replied, "Lady come, man come, moose come, sheep come ..."

The club president quickly retorted, "Oh, you busy guy!"

Charles has now lived in the Chinatown area around Dundas and Beverley for forty years. Why does he love Chinatown?

Well, the neighbourhood is at the epicentre of Toronto, and although it isn't obvious, it is changing faster than you can swallow a dim sum. It has a way to go before it becomes gentrified like Yorkville or Cabbagetown. The 1880s Victorians are still a mishmash of styles reflecting their owners' ethnicities. But with the elegant new AGO and redesigned Grange Park on the Beverley Street border, and the bustle and cacaphony of Spadina Avenue a block west with high-rise condos sprouting up and down the Avenue, Chinatown is beginning to transmogrify. A white brick office building at the southwest intersection of Dundas and Beverley now boasts a Chinese-style Pusateri's supermarket on its main floor called 'Lucky Moose Market,' with one of the remaining Melmooses from the Moose in the City project repainted and installed high up, sporting a set of Fu Manchu whiskers. It looks out over the porticoed yellow brick current Italian consulate, formerly Chudleigh House, the grand nineteenth-century mansion of Sir George Beardmore, one of many stately aristocratic abodes that lined both sides of Beverley Street when it was the Post Road of the gentry of the old town of York.

Five minutes from everything — Tintoretto, the Group of Seven, and the Renaissance at the AGO, fresh strawberries at ninety-nine cents a box, peeled garlic, exotic fish from around the world, dollar stores, and cute hole-in-the-wall restaurants where you can get a bowl of hot and sour soup, steamed chicken with ginger and onion for under 10 bucks, and then take home barbecued duck, pork, and other assorted culinary wonders for the last-minute dinner guests.

With his many moves and his ups and downs, Charles has reinvented himself many times. Because he was often being clobbered in the mainstream press by art critics with hyphenated names, and since in post-colonial Canada art critics with hyphenated names seemed to be taken more seriously, Charles invented a few fake art critics to wax lyrical over his work. He often took out ads in the *Star* and *Globe* with quotes from them. His best-known critic was Don Rouge-Humber, who felt Pachter's art was "so stunning, words fail me!" and that Pachter was "a legend in his own mind."

When a German lumber baron bought six of his paintings, including a moose and a flag, the first question Charles put to him was, "How did you hear about me?"

He responded, "I have known of your work for years, but I read zis glowing review in the *Globe* from Don Rouge-Humber."

Charles didn't want to lose the sale, but felt he had to confess. "Um, there's something I should tell you. I made him up. He's my alter ego."

The man replied, "In zat case do I write ziss check to you or to him?"

In a moment of breathtaking art-speak, Don Rouge-Humber called Charles's work "a mnemonic mimesis of metaphysical mooseness." Atwood, feeling he should also have a female art critic, created Avon St. Laurent, who described his work with great

Charles dressed as his alter ego, art critic Don Rouge-Humber.

perceptivity as "light as a feather, swift as a wave and solid as granite." And finally, for his *Ducks Redux* show at the Orillia Museum, he invented local art critic Trent Severn, who got quoted in an ad in the *Orillia Packet and Times*, exclaiming, "Pachter gets right to the Heart of Duckness."

With his delight in word play, something that dates back to his childhood, it is no surprise that Charles loves to write as well as paint; in fact, he is also a well-regarded author. He has written and/or illustrated four children's books: The first was *Wiggle to the Laundromat*, poems by Dennis Lee, a book commissioned in 1970 by Anansi publisher Dave Godfrey for which Charles did the illustrations. He created *The Queen of Canada Colouring Book* in 1977, a droll book suggested to him by Jim Polk, depicting First Nations chiefs, Mounties, Brownies, schoolgirls, and others curtseying to the queen. Some booksellers in Canada thought it was irreverent and wouldn't stock it. In 2008 Cormorant Books publisher Marc Côté asked Charles to create *M is for Moose*, an educational, alphabetical, love poem to Canada, which has sold twenty thousand copies since its publication. Its sequel, *Canada Counts*, a counting book, was published in 2009.

Even for a man as resilient as Charles, there are times when events overwhelm and words fail. On July 9, 2007, at the age of ninety-two, after a life full of style, adventure, and joy, Dibbles died. She had previously told Charles that she wanted a simple, non-religious funeral. Over six hundred people showed up at the Holy Blossom on a mid-summer Monday. They heard a beautiful eulogy by Rabbi Yael Splansky, and listened to an affectionate speech by Charles recounting some of her best one-liners. The shiva was held at the Moose Factory, where hundreds of letters arrived from her friends, relatives, and clients, including one from Israel's ambassador to Canada.

Six days later Bluma Appel died. When the CBC called Charles to ask for a comment about Bluma, he said, "I lost two mothers in one week."

A few months later Christopher Bunting, director of CANFAR, asked Charles to donate a major painting for their fundraiser. Charles gave them one of his best flag paintings. When asked to speak, he took to the stage, looked up over the audience in Koerner Hall, and said, "No one worked as diligently for this cause. Bluma, this one's for you."

The painting was purchased by Toronto philanthropists Janice and Earle O'Born, who donated it to Canada House in London. They invited Charles to join them in London in February 2015, when the queen and Prince Philip officially opened the newly renovated building.

CHAPTER 19

The Queen and I

For decades Charles has been fascinated by royalty, its history, its pageantry, and its scandals. He has met a considerable number of royals over the years, the first being Princess Margaret in 1988. The occasion was a summer garden party held at the estate of Lady Eaton in King City. The Princess smoked heavily and was a bit tipsy when she was introduced to him by then-Premier David Peterson. When he told her that Charles was the artist "who painted your sister on a moose," she asked, "a *mousse au chocolat?*"

A year later, unable to attend a luncheon for the Queen Mother to which she had been invited, Margaret Atwood gave him her ticket, and he in turn invited Marcia McClung and Barbara Kingstone to the event. Arriving at the King Edward Hotel, they walked up the red carpet to clicking cameras, policemen everywhere, and hordes of Shriners waving flags before heading into the Vanity Fair Ballroom.

Once inside Charles noticed a lot of white women dressed in polyester gowns and huge floppy hats, with matching bags and gloves. The only black person in the room was Lieutenant-Governor Lincoln Alexander with his wife Yvonne. Suddenly there was a trumpet fanfare. Everyone stood for a couple of minutes in complete silence. Because the Queen Mother was so tiny, all Charles saw was a single feather making its way across the floor, preceded by dignitaries. When he finally saw the Queen Mother herself, she was wearing her signature pirate hat. Her bearing was remarkable, considering that she was eighty-eight years old and was known primarily for putting away a gallon of booze a day.

THE QUEEN AND I 149

After a welcome by Finance Minister Michael Wilson, Her Petite Majesty rose and in her speech said, "When the King and I arrived here in 1939, Toronto was a very different city. There was no SkyDome."

A year later Charles was invited by Hilary Weston, the lieutenant-governor of Ontario at the time, to the Distillery District, where he was introduced to Prince Charles by John Fraser as "one of our great Canadian artists."

Charles said, "Your Highness, it is a pleasure to meet you. I would like to present you with a postcard of a painting I did of your mother riding a moose."

The Prince cracked up and asked, "Do you have copies for Harry and William? I'd like them to see Granny on a moose!"

In 2013 Anthony Hylton, aide to David Onley, then lieutenant-governor of Ontario, asked Charles if he'd like to meet Princess Anne when she was visiting Toronto.

"Of course," Charles replied.

Donald Macdonald of Orillia had previously sent Charles a photo he took of a female moose jumping a fence, which Charles digitally altered to make it look like Anne was riding the moose.

Anthony Hylton's response was, "It's adorable but it has to be vetted by Buckingham palace."

When the palace gave the okay, Charles mounted and matted the print, and showed up at Queens Park on October 23, 2014, at 4 p.m.

Surrounded by a crowd of dignitaries munching viceregal hors d'oeuvres, Charles was introduced to Princess Anne as "the famous Canadian artist who painted your mother on a moose." Charles then unveiled the print of her on mooseback, jumping over a fence. Princess Anne looked at it, smiled, and exclaimed, "The moose doesn't have any antlers. What do I have to grasp on to?"

Charles replied, "With respect, Your Highness … firm thighs."

A few months later, this picture of her riding the moose was published in British papers as one of the most outlandish Christmas gifts received by the royals that year.

A year later Charles was asleep early one Saturday morning when a man knocked on his door at Pachter Hall and said through the intercom, "Hello, I hope you don't think I'm stalking you. I'm from London and I've come to see your gallery."

Charles replied, "Could you come back in an hour? I need to shave and get dressed."

The man left, returned in an hour, and introduced himself as Simon Vincent, from Dorking, Surrey, United Kingdom. He was general manager of the Trafalgar Hilton hotel in London, directly across the street from Canada House. He ended

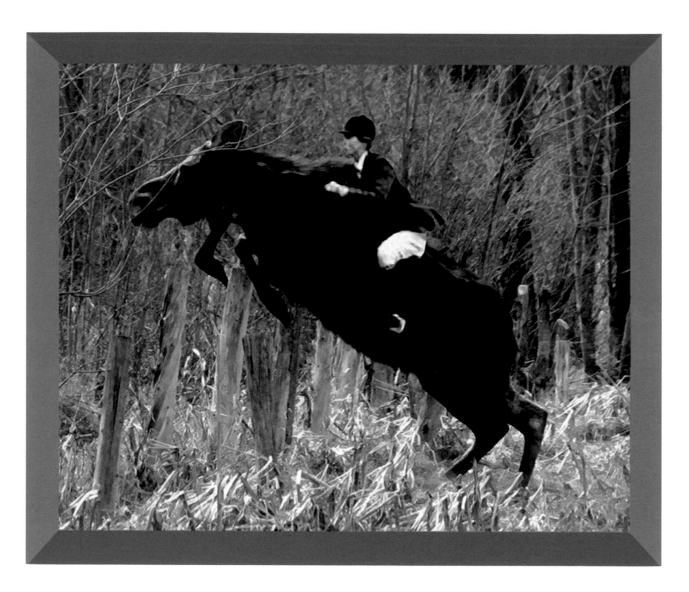

Royal Broad Jump,
inkjet, 2014.

up buying the painting *Love Pat* of the gloved queen patting a moose, and the print, *Decisions, Decisions,* of Her Majesty at her bedroom closet deciding which hat to wear.

When Charles received the invitation to the Canada House reception in London, he called Simon Vincent and asked if he could get a room at the Trafalgar Hilton across the street.

"Of course," said Simon. He was also offered the lobby of the hotel for an exhibit of his paintings.

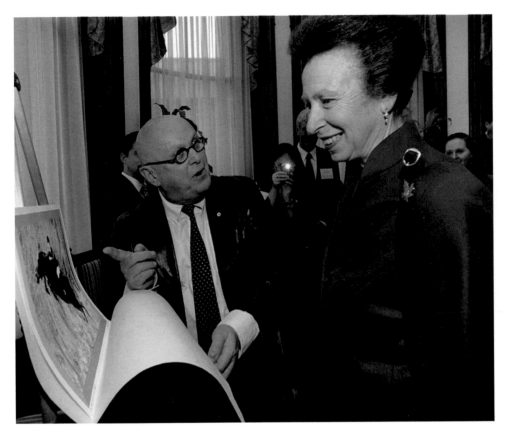

Charles presents Princess Anne with his print of her riding a moose.

When he arrived at Canada House to meet the queen, Charles was asked by Janice O'Born what cluster number he was in. Cluster? Finding no number on his invitation, at Janice's bidding he wrote on it "Cluster #1" so that he would be in her group. Wearing his medals, blazer, and shiny new shoes, he was ready and waiting. The queen and Prince Phillip, however, were a half hour late as they were stuck in traffic.

When they finally arrived, Her Majesty was welcomed by the High Commissioner and ushered into the foyer where she passed by Charles's flag painting hanging on the wall beside them. Seeing Charles standing in Cluster #1, wearing his medals, the queen came straight over to him.

Dibbles spoke to him from heaven: "Don't wait until she speaks, go right ahead and talk to her." So he did.

"Your Majesty," he said, "this is such an honour. Forty-three years ago I painted you as the queen of Canada riding a moose, and it became one of my best-known images. Thanks to you I've made a living all these years."

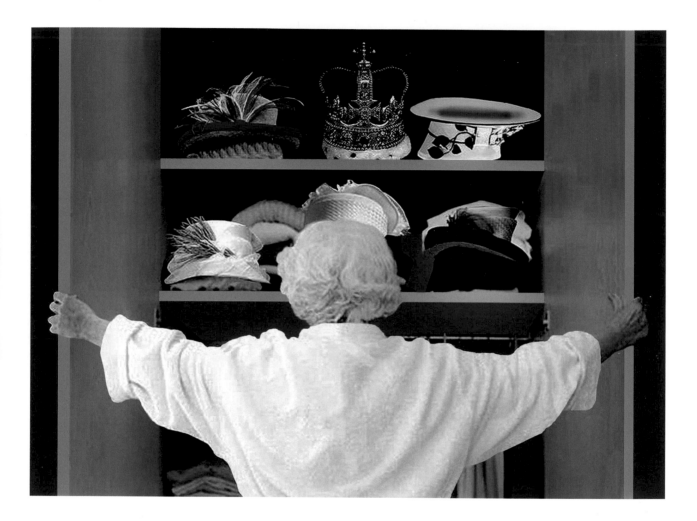

Decisions, Decisions, 2014.

She smiled radiantly, and said, "How amusing!"

The exchange lasted only thirty seconds but that was long enough for a Reuters photographer to take their picture. The next morning the byline "Artist who painted *Queen on Moose* meets queen" was in the *Daily Telegraph*. Charles emailed the photo to John Honderich, the publisher of the *Toronto Star*, who published the 1973 picture of Charles with *Queen on Moose* next to the 2015 picture of him meeting the queen in London.

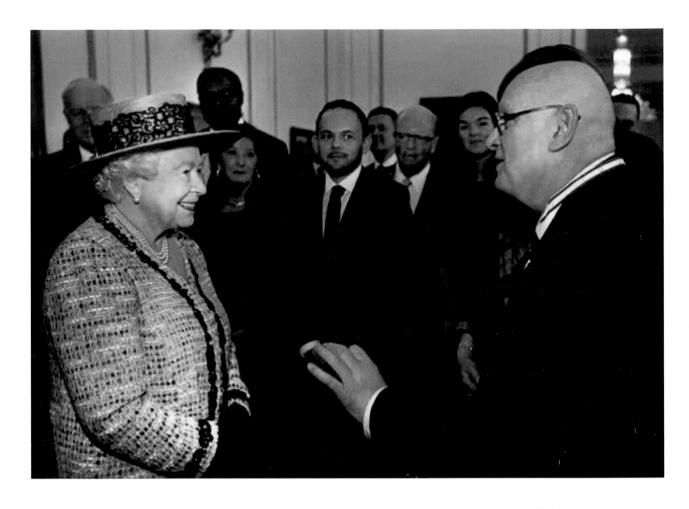

Charles meets the queen at Canada House in London, February 2015.

CHAPTER 20

From Lake to Town

In 2002 Charles turned sixty. After owning a farm for five years and a winter home in Miami Beach for six years, he began to yearn for the Lake Simcoe of his childhood.

Going online for the first time, he found a FOR SALE BY OWNER ad for a former ice house, a structure created for storing the blocks of ice that were cut from the lake for use in ice boxes before refrigerators came into use. According to the ad, the building was situated right at the water's edge, "with a panoramic view of Lake Simcoe." The owner was asking $230,000 for it but admitted that it needed work.

Charles went to see it and, even though it was in bad shape, he fell immediately in love with the setting and the potential. Charles offered $210,000, with one of his own paintings thrown in.

"What do I need a painting for? I'm from Scarborough," responded the owner. So no deal.

A year later Charles noticed that the building was still for sale. He went back to the house for a better look and found it to be an ugly "Early Swiss Bavarian Tudor Nazi" cottage, with swirly plaster walls and ceiling, and fake Styrofoam wood beams, but the views of the lake were stunning. Charles bought it for $225,000 and hired two OCAD University graduates, Nick denBoer and Peter Mitchell from Toronto, to gut and rebuild it.

For the next twelve summers Charles delighted in his Zen retreat, the large, bright studio and the superb panoramic views of the lake. At the Ice House he completed over one hundred paintings, including thirty paintings for two major exhibitions — *1812: The Art of War*, the whole of which was acquired by the City of Toronto for the new

Fort York; and *Lest We Forget*, a series of paintings on the First World War, shown at the Lieutenant-Governor's suite at Queen's Park in 2014–15.

Not only was the Ice House the locale for the creation of many inspired works by Charles, it was also a place that allowed him to host many visits by friends and family. Each summer he welcomed hundreds of guests. Despite this, he was often lonely. One of the hardest things, he found, was being a single gay man surrounded by neighbouring cottagers, the many straight couples who came over to sit and schmooze on his deck, sipping on their drinks and asking, "Is this Smirnoff or Stoli, because I don't drink Smirnoff." By 2013 Charles felt that this part of his life was coming to an end.

His friend Marcia McClung agreed with him. "Time for a change," she told him. "You need a project."

Charles soon found himself a new project and, more importantly, someone to help bring him unexpected happiness.

Former ice storage depot on Lake Simcoe converted to studio and residence, 2004.

During his sojourns in the Ice House, Charles continued his frequent trips into Orillia to buy butter tarts at Wilkie's and to shop at his temple, the local Goodwill store. Old habits die hard. One day he drove down a quiet lane near the Goodwill. A FOR SALE sign caught his eye. Charles had always been attracted to lanes and alleyways in downtown Toronto. The sight of an abandoned 2,400-square-foot car repair shop with an empty lot next to it (also for sale) reawakened the real estate junkie in him. Next thing he knew, he had bought both.

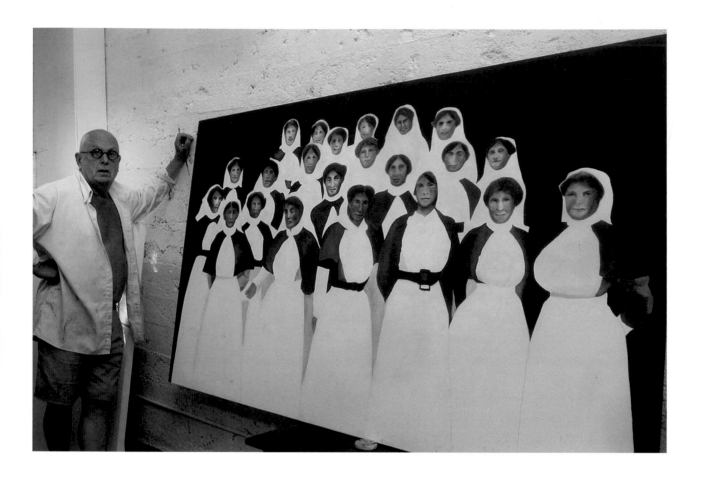

Charles painting *The Healers* in the Ice House studio, for the exhibition *Lest We Forget*, 2014.

He spent a year renovating the car repair garage. When it was finished, he had created a studio plus living loft he named MOFO, Moose Factory of Orillia, not realizing that MOFO meant "motherfucker" to those in the know.

After Charles shifted his northern base of operations to MOFO, he gradually got to know Orillia, the charming, small Canadian home town of Gordon Lightfoot, Franklin Carmichael, Stephen Leacock, and Elizabeth Wyn Wood. The more he got to know it, the more he liked it. He would soon become an even bigger fan of the town.

On July 30, 2015, Charles was working in his Orillia studio. The entrance door was open. A handsome guy in shorts and a Superman T-shirt happened to walk by.

Charles sneezed.

The guy said, "Bless you."

Charles thanked him and then invited the guy in and showed him around.

MOFO, Moose Factory of Orillia, studio and residence, 2016.

He learned his name was Keith Lem, that he was forty-nine years old and a native of Orillia, and that his parents had run the Golden Dragon, Orillia's best-known Chinese restaurant, for the past fifty years. One of a family of seven children, he was still living at home with his mother and sister.

Charles continued the tour of MOFO. After showing him the sleeping loft, he asked Keith to scratch his back. The rest is history.

On Orillia's Starry Night in August 2015, when artists open their studios to the public, Charles did so, too, and many of Keith's brothers and sisters showed up to meet him. This was the first time that Charles had met them and, obviously, it was the first time that his family had seen Keith and Charles together. Later one of Keith's sisters asked, "Are you two an item?" Charles smiled.

The developing relationship between Charles and Keith caused a profound change in Charles's life. Like many artists, Charles needs solitude as much as intimacy. For years he couldn't handle someone living with him because it distracted him from his work. The Charles paradox, according to John Fraser, is that "he's only happy when he's surrounded by people, and he's only happy when he's on his own." In other words, a gregarious loner. Keith only wants to be there for him when he wants him. They have a wonderful cosmic relationship. Keith is also a very talented artist, happy to learn from his mentor. Keith decided to quit his job in Orillia and is now Charles's

Charles and Keith, 2016.

assistant at MOFO, where he and Charles spend much quiet time working together, and at the Chinatown studio in Toronto.

From the MOFO live-work space that he shares with Keith, Charles has continued to explore Orillia and the area around it. Since early childhood Charles has had second homes near Orillia, and over the years he has gotten to know the area better. In his travels, one of the things he noticed when he exited Highway 11 along Memorial Avenue was the huge expanse of rolling hills and meadows stretching down to Lake Simcoe, with many historic buildings of interest scattered like a college campus, similar to the University of Toronto or Yale. After some investigating, Charles found out that it was once the Huronia Regional Centre, a notorious institution that, for decades, housed developmentally challenged patients. It was closed down by the province in 2009 and is currently mostly vacant, with just a few of its buildings occupied by the OPP and the Orillia courts. The site fascinated Charles.

One October afternoon Charles discovered a trail off Woodland Drive that meandered right down to the lake, so he went exploring. He was astonished by the beauty of the waterfront and the wetland marshes, and dismayed by the boarded-up cabins and cottages dotting the shoreline. He started to wonder why this site was no longer in use, and how or when it could be transformed. He knew that Orillia had lovely parks and trails, but the Huronia site, with its chapel, studios, gymnasiums, classrooms,

dormitories, workshops, administration buildings, handsome residences, and industrial facilities, was unlike anything else he had seen around town. Charles began to think about possibilities — it could be an international arts destination, a cultural campus for the creative and performing arts serving south-central Ontario, a vibrant future hub for Orillia and the Simcoe County region in terms of employment, tourism, education, innovative programming. For Ontario, and for all of Canada, it could serve as something akin to the Banff Centre in Alberta, the Chautauqua Institute in western New York state, or Tanglewood in Lenox, Massachusetts. He knew that transforming the facilities would take immense effort and funding, and that it required a long-term vision. Charles also knew that similar venues had been successfully created in several other places in North America.

Site of the Huronia Regional Centre, Orillia.

Internationally acclaimed Internet guru Don Tapscott, a native of Orillia, has been an enthusiastic supporter of the Huronia Cultural Campus concept. "I think this could be the most important thing for Orillia since the arrival of Samuel de Champlain," he says. An Orillia-based steering committee has been working diligently to help drive the project forward. It includes local residents Will McGarvey, Don Ross, Anderson Charters, Fred Larsen, Debbie Woodman, Dennis Smith, and Chris Hazell.

Since Charles built his studio in downtown Orillia with a new attached residence, he has invited author Margaret Atwood, tech whiz Don Tapscott, business executive Bonnie Brooks, and public-policy specialists Anne Golden and Helen Burstyn to become honorary members of the Huronia Cultural Campus Foundation, and they have accepted with enthusiasm. Charles envisions a repurposed facility that could include a performing arts centre for symphony orchestras, ballet, opera, and theatre; an international sculpture symposium with a sculpture park for permanent installations, and commemorative monuments focusing on the history of the site. Foundries could be set up in the old buildings, and sculptors could come from around the world to work. Other facilities could include live-work studios for artists, writers, and musicians; a media centre for innovation and research into the digital economy; a First Nations art gallery and museum; a Canadian Folk Music Hall of Fame; a conference centre with hotel accommodations; and an education centre and gallery honouring former patients. Community-focused projects could include preservation of the natural shoreline and wetlands. Students from universities and colleges across the province could come and study visual and performing arts at the centre during the summer. The abandoned mansions on-site could become restaurants, tea houses, a culinary institute with organic vegetable gardens on-site, and VIP accommodation.

Of Charles's work on the project, Don Tapscott has stated:

> Charlie reminds me of a British bulldog bringing down a bull. The harder the bull tries to get away, the more the dog sinks its teeth in. That's Charlie on this Huronia project. He'll never let go of this vision till it becomes reality. He's the driving force behind it. There are a million reasons why it might fail, but I'm convinced it could happen. People like being around Charlie. Wherever he goes there's something happening. He's always on message and doesn't deviate from his objective. He's not just a visionary or strategist or facilitator. He's like a little tornado, a force of nature. He'll do whatever it takes to see it come to fruition.

At two MOFO summer events, Charles auctioned off fifty of his artworks to raise $150,000 for the Orillia Museum of Art and History. Orillia was once a vibrant manufacturing centre, and its history, heritage architecture, and beautiful setting between two lakes convinced Charles of its tremendous potential. The cost of real estate is also a fraction of that of Toronto.

EPILOGUE

Charles is now seventy-four. If you think he's merely a good-time Charlie, take a look at his fingernails that have been eaten away by the ink and acid he has used in printmaking, and by the acrylics he has painted with over the years. Yet he returns regularly to his studio in his paint-spattered pants, working for hours on end in the precarious ritual of making images. If the work of his youth powerfully explored his inner angst, he soon graduated to satirizing his mother's bridge club partners in his painting *The Hiya Dolls*. He then moved out to an external world, reimagining the iconography of his city, his country, and its history, with uniquely branded Pachter images — streetcars, the queen, moose, flags, barns, Susanna Moodie, John Graves Simcoe, Loyalists. As Julian Barnes has written, "Art tends, sooner or later, to float free of biography."

He confides to me that if and when he is approaching the final chapter, he would like to rest comfortably on Auntie Annie's couch in his loft, with sunlight pouring in over the treetops through the high windows and skylights, surrounded by his art and some butter tarts from Wilkie's, with friends and family, accompanied by Ethel Merman singing Sondheim's "You'll Never Get Away from Me."

He tells young artists who hope for early success to "spread the rumour that you're dying, while you continue to live a life full of joy and passion."

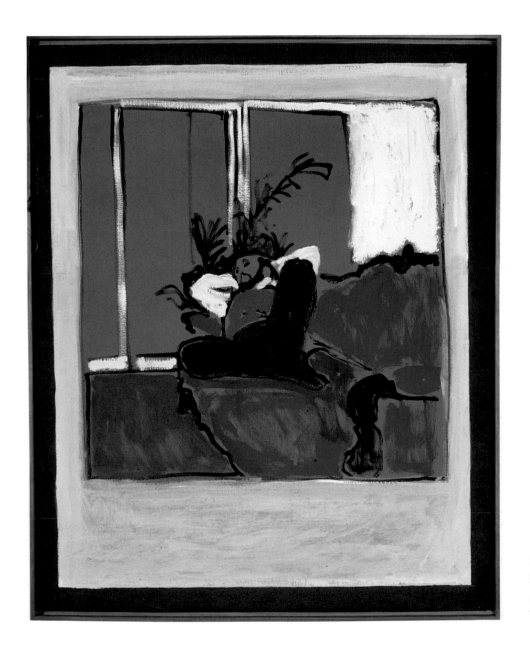

Self Portrait on Davenport, acrylic on canvas, 1978.

(Private Collection, Toronto.)

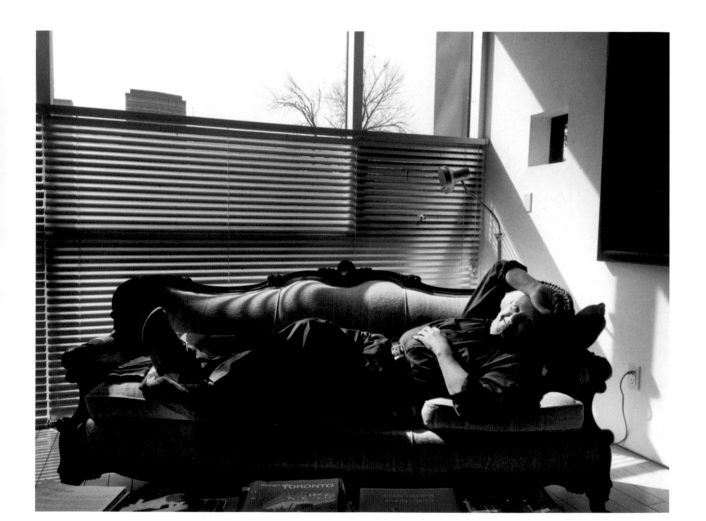

Charles reclines on the
davenport, April 2016.

CHRONOLOGY

1942

December 30, born in downtown Toronto, the second of four children, to Harry and Sara Pachter.

1946–50

Family moves uptown.

Attends John Ross Robertson Public School and Holy Blossom Temple.

Spends summers at various cottages around southern Lake Simcoe.

1947

Stars in *Johnny at the Fair,* a National Film Board documentary about the Canadian National Exhibition. During the filming, he meets Prime Minister Mackenzie King; gets kissed by figure skater Barbara Ann Scott; pets a moose.

1950–55

Family moves again.

Attends John R. Wilcox Public School.

Studies piano with Rachel Cavalho, painting with Ronald Satok.

1955–60

Attends Vaughan Road Collegiate. Takes academic art course under Miss Hudgins.

1957

Paints large mural on his bedroom wall of the Canadian landscape on the $2 bill.

1958

Dr. Verna Curran encourages his French studies. Goes on a *visite interprovinciale* exchange program hosted by a family in east Montreal. Sees Quebec City.

Paints sets for musical shows at Camp Katonim, Lake Simcoe.

Discovers the unused attic of the family house, which he turns into a private space where he works and paints for two years.

1959

Attends an arts festival in Great Barrington, Massachusetts, where he paints a landscape in oil.

Builds a portable ark for Holy Blossom Temple school.

Invited to Saturday morning classes for gifted adolescents at the Art Gallery of Toronto, supervised by William Withrow.

Chosen Simpson's representative for Vaughan Road Collegiate. Paints a wall mural of a prairie road for the Home Furnishings department of Simpson's department store; models for Simpson's catalogue.

1959–64

Spends summers teaching arts and crafts and drama at Camp White Pine, Haliburton, Ontario. Creates special events programming. Meets and befriends Margaret Atwood, head of the nature program.

1960–62

Heads the arts and crafts department at Holy Blossom Temple School.

Enrols in Art and Archeology at University of Toronto, taught by Steven Vickers, Robert Welsh, Scott Symons, and Ted Bieler. Fellow classmates include Bogomila Ovcharov and Douglas Richardson.

1961

Takes night courses in silkscreening under Fred Hagan at Ontario College of Art.

Sketches with Ed Roman in the Rouge River Valley. Paints watercolours and oils of local landscapes.

1962–63

Studies at the Sorbonne in Paris, and travels around France, Spain, Italy, and Corsica. Makes figure drawings and watercolours at the Académie de la Grande Chaumière, as well as streetscapes in and around Paris.

1963–64

Returns to Canada, completes Honours B.A. at the University of Toronto.

Visits Chicago to see houses of Frank Lloyd Wright.

Makes silkscreens at Camp White Pine and in his studio in Mirvish Village on Markham Street. Makes large oil paintings *Reminiscences of a Euclid Avenue House* and *Horseforms*.

February 1964: First solo exhibition of serigraphs at Pollock Gallery on Markham Street. Works exhibited include, *Birds in Flight, Family,* and *St. Lawrence Market.*

1964–66

Enrolled in the Graduate Studies program at Michigan's Cranbrook Academy of Art. Studies papermaking, lithography, silkscreening, etching, painting, design. Corresponds with Margaret Atwood. Prints five limited-edition illustrated folios of her poetry. Produces lithographs, *Prism, Who is Sylvia?, Couple, The Myth,* and *Two Plus One.* Paints first realistic satirical work, *The Hiya Dolls.*

Visits Cuernavaca and Tepoztlan in Mexico.

1966

Graduates with an MFA from Cranbrook, then returns to Toronto. Sets up a printing studio at 907 Shaw Street; rents rooms to friends.

Prints lithographs *The Winner, Funny What Love Can Do, Golem,* and *Conflux.*

Acquires fonts of old foundry type. Makes handmade book of lithographs, *Notebook Pages,* illustrating the poems of John Newlove. Joins Quadrat Society of private-press printers at Massey College.

1967

Moves to Montreal. Works in the theme division of Expo 67, and installs sculptures for the Exposition Internationale de Sculpture Contemporaine. Meets Alexander Calder; prints lithographs *Masque* and *Body Politic* in the Atelier Graff of Pierre Ayot.

Musée d'Art Contemporain buys first Atwood-Pachter portfolio, *The Circle Game.* Limited-edition books purchased by Montreal dealers Joseph Amtmann and Laurie Lerew.

1968

Returns to Toronto. Buys first house, at 1232 Shaw Street. Builds a printing studio in the basement with separate entrance.

Makes lithographs *It's Just a Flesh Wound, Champêtre, Invocation, Is the Pope Catholic?* Prints handmade book of poems by Alden Nowlan, *A Black Plastic Button and a Yellow Yoyo.*

March: Exhibits lithographs at Gallery Pascal, Toronto.

Visits France, Greek islands.

Begins psychotherapy.

1969–70

Invited by Dean Richard Johnston to teach at the University of Calgary.

Exhibits new graphics at Canadian Art Galleries, Calgary.

Makes lithographs and silkscreens *Elegy for Bluebeard, Lookout, Model Modern Message, She'll Be Comin' Round the Mountain, Happy Trails to You, O Bury Me Not, Beatific Revelation, Plunge, Deluge.*

Works with artists John K. Esler, Anthony Benjamin, and Alexandra Haeseker.

1970

April: Returns to Toronto. Begins major renovation project for house and studio at 1232 Shaw Street.

October: Second exhibition of graphics at Gallery Pascal.

1971

Makes several editions of streetcar serigraphs.

December: Tours the Middle East; returns to Canada, flies to Cape Dorset, North West Territories, to teach lithography to the Inuit. Takes ill, is flown south.

1972

January–February: Recuperates at Toronto Western Hospital.

April: Exhibits streetcar graphics at Isaacs Gallery.

Sets type, illustrates Dennis Lee's book of children's poems, *Wiggle to the Laundromat.*

July: Visits the Gaspé Peninsula to see a full eclipse of the sun.

Returns to Toronto; begins series of paintings examining the monarchy in Canada, a series that includes *Procession Through Landscape, Noblesse Oblige (Queen on Moose), The Visitation, Double Bubble, Rite de Passage, Clair de Lune, The Curtsey Triptych,* and *Snow Queen.*

1973

June: Opens *The Other Shaw Festival,* for his exhibition of new paintings, *Monarchs of the North,* at 1232 Shaw Street. The opening of *The Other Shaw Festival* was timed to coincide with the queen's visit to the Shaw Festival in Niagara-on-the-Lake.

Buys an old factory at 24 Ryerson Avenue near Queen and Bathurst Streets.

Continues painting and printing; works focus on themes such as landscapes, moose, rocks, goats, and Canadian Tire collages. New works include *Flight of the Toaster, Mooseponder,* and *Lakemark.*

1974

August: Moves to 24 Ryerson Avenue. Founds Artists Alliance Building Limited.

Starts artists' co-op gallery called Artery. Moves to top-floor loft, where he lives and works for two years. Discovers derelict factory next door, which he helps director Paul Thompson purchase for Theatre Passe Muraille. Buys and renovates neighbouring warehouse buildings as extensions of Artists Alliance.

October: Holds huge event party to mark the opening of the Artery. Event coincides with opening party of Stage II, new wing of Art Gallery of Ontario.

1975

February: Exhibits Landmarks at Artery. Show includes paintings *Look Out Barbara Ann* and *Kippawa* and prints and collages, *Mooseponder* and *Moosamour.*

Chairs an Art Gallery of Ontario citizens' committee advocating wider community participation on the gallery's board of trustees.

Conceives two "performance art" group shows exploring taste: *The Ugly Show* and *The Stunning Show.*

1976

Moves to and restores house at 350 Markham Street. Forms Pungent Productions, a renovation company, with partners John Stewart and John Eckler.

Paints large work, *Life Is Not a Fountain*; silkscreens *Mooseplunge.*

Joins Artists with their Work program at the Art Gallery of Ontario.

Lectures and shows in Kingston, Ottawa, Owen Sound, Simcoe, Hamilton, and Sudbury.

June: Buys one-hundred-acre farm in Oro-Medonte Township near Orillia.

House of Anansi Press publishes *The Queen of Canada Colouring Book* with Pachter drawings and quips.

1977

August: Purchases a derelict grocery store and blacksmith's shop near Grange Park, at corner of Sullivan Street and Grange Place. Renovates it into a permanent home and studio.

September: *Collins, Pachter, Tinkl* exhibition opens at the AGO.

1978

Paints ink-and-drybrush portraits of friends, *Figures in a Landscape,* from Oro farm and Lake Simcoe.

December: Visits Paris for Michael Snow exhibition at the Pompidou Centre.

Paints ink-and-drybrush portraits, *David Earle, Peter Randazzo, Joyce Wieland, Catherine Williams, John Hirsch, Peter Newman, Rick Salutin, Susan Swan,* and *Margaret Atwood.*

Renovates 78 Sullivan Street for Lester and Orpen Dennys and 367 Queen Street West as the Soho Loft Gallery.

1979

October: *Figures in a Landscape* solo exhibition opens at his Soho Loft Gallery. Works featured include, *Six Figures in a Landscape, Self Portrait on Couch, A Pause on the French River, Convertible in a Landscape, Monika at Oro,* and portraits, *Alix Arnett, Gwendolyn MacEwen, Wendy Weaver,* and *Michael Snow.*

1980

Purchases Remenyi House of Music building at 553 Queen Street West; opens Ring Gallery; hires director Judith Saunders.

Resumes work on Margaret Atwood's *The Journals of Susanna Moodie.*

With ten partners, renovates a furniture store at 508 Queen Street West for eventual use as Gracie's Restaurant.

October: Exhibits *The Journals of Susanna Moodie* and new portraits at Ring Gallery. Begins renovation of former IGA supermarket building at 567 Queen Street West.

November: Gala opening of Gracie's Restaurant.

1981

Invited to exhibit in *Artists in Books*, at the National Library, Ottawa.

April: Starts series of large flag paintings.

November: Opening of *The Painted Flags* in the new IGA Gallery, Toronto.

1981–82

Recession. Gracie's closes. IGA Gallery closes. Artists Alliance closes. Business partnerships end. All real estate holdings are sold, except house and studio.

Invited to show in *Post-Pop Realism: The Winnipeg Perspective*, Winnipeg Art Gallery, Winnipeg.

1983

Three large flag paintings are acquired by Olympia and York.

1984

March–July: Exhibition of paintings and graphics at Mövenpick restaurant gallery, Toronto.

July: *The Journals of Susanna Moodie* opens at the Art Gallery of Ontario.

November: Invited to show in the group exhibition *Vestiges of Empire* in London, England.

December: *Waterworks*, one-man exhibition of new paintings, opens at Queen's Quay Terminal, Toronto.

Sees *The Mystic North* exhibition at Art Gallery of Ontario. Creates paintings of Loyalists, historical and contemporary figures, and objects in Group of Seven–style landscape settings. Works include, *Simcoe's Reward, Cold Comfort, Davenport and Bay, Lake Couch-I-Ching, Queen's Rangers,* and *Castle Frank in Winter.*

1985

April–October: *Regarding the Flag*, exhibition of twenty flag paintings celebrating the flag's twentieth anniversary, Ontario Science Centre, Toronto.

September: *Waterworks*, The Arts and Letters Club, Toronto.

November: Goes with parents on their tour of Tokyo, Kyoto, Taiwan, Bangkok, Singapore, Macau, and Hong Kong.

New paintings: *The Supremes, Float, Bare in Mind the Light, State of the Tarts, To All in Tents, Gait, Arcade, Revelation.*

Begins series of fifty line-drawing portraits of prominent Canadians for *City and Country Home* magazine.

1986

April: Gallery Moos, Toronto. Works exhibited include *Rapprochement, The Supremes, Mooseplunge, Float, Discovery: The Canvas House, Sealed Off,* and *Constitutional.*

July: Purchases and renovates 80 Beverley Street, six-apartment building across from the Art Galley of Ontario, Toronto.

1987

January: Alliance Française, Toronto. Works exhibited include *Tour de Force, To All in Tents, Une Demoiselle de Toronto, Oro Barn,* and *Cipher.*

February: Documentary profile *Pachter*, directed by Claude Grenier, debuts at the National Film Board offices, Montreal.

April: Exhibits at Ryerson Polytechnic Institute, Toronto.

Writes series of articles on art and architecture for the *Toronto Star.*

1988

Makes computer-generated sketches for paintings *Red Barn at Oro* and *Red Barn Reflected.*

Starts diary on computer.

November: La Citadelle, Montreal. Paintings exhibited include, *State of the Tarts, A Cross the Lake, Ann at Oro, Moose Stall, Catherine Williams, Life Is Not a Fountain,* and *To All in Tents.*

1989

February: Paints commissioned portraits of Bogomila and Robert Welsh, Marilyn Lightstone and Moses Znaimer, Eva and Edward Borins, and Pauline Elias.

Paints *Sir Who, Moose Lake, Flagspatter, Buy Lingual,* and *Oro Barns Seen from My Window.*

December: Visits Delphi, Athens, and Paros in Greece with Merike Weiler.

1990

April: Exhibit of new works at Castle Hill model home. Works exhibited: *Ari Air View, Ordinary Canadians, The Once and Future King, The Rosedale Kiss, Night Ride, Black Lit Clark, Sealed Off, Round Square.*

July: Mural *Voice of Culture* for exterior wall of Acme Bar and Grill, King and John Streets, Toronto.

August: Visits Bogomila and Robert Welsh in the south of France.

September: Paints three portraits of Pierre Trudeau and two portraits of Van Gogh as a young man: *A la recherche du jeune Vincent, Vincent au lit.*

1991

June: Solo exhibition, *The Summit,* Canada Trust Tower, Toronto-Dominion Centre, Toronto.

July: Inniskillin Winery, Niagara-on-the-Lake, Ontario.

October: First European retrospective: Centre d'Art Présence Van Gogh, Saint-Rémy-de-Provence, France.

1992

April–June: *Claridge Collection: Twenty-Fifth Anniversary,* Saidye Bronfman Centre, Montreal.

Charles Pachter: Retrospective exhibition, Haus an der Redoute, Bonn, Germany.

1993

July–September: *The Simcoes and the Founding of Toronto*, Art Gallery of Ontario, Toronto.

1994

February–October: *Charles Pachter's Canada*, Royal Ontario Museum, Toronto.

May: *Pachter's People*, Mövenpick gallery, Toronto.

November: *Pachter West*, Barton-Leier Gallery, Victoria, British Columbia.

1995

June–October: *In Pachter's Orbit*, CN Tower, Toronto.

1996

September–October: *La Transhumance*, Alliance Française, Toronto.

1997

February–March: *The Visitation*, Italian Cultural Institute, Toronto.

Hockey Knights in Canada, Canadian Embassy, Washington, D.C.

1998

The Barns Exhibit, Moose Factory Gallery, Toronto.

1999

June: *Charles Pachter: Portraits*, University of Toronto Art Centre, Toronto.

2000

February–August: *Charles Pachter: Graphic Work*, Design Exchange, Toronto.

June: TEDCity Conference, St. Lawrence Centre, Toronto.

2001

April–June: *Mind's Eye: A Charles Pachter Retrospective*, Canadian Embassy, Tokyo.

September–November: *L'Être au Monde*, Centre d'art de Baie-Saint-Paul, Quebec City, Quebec.

2004

May–June: *Charles Pachter Retrospective*, Spin Gallery, Toronto.

October 4, 2004–March 5, 2005: *Canadian Icons*, Maggie's Gallery, London, Ontario.

2005

September 5–26: *Charles Pachter: Selected Works*, The Spoke Club, Toronto.

November–December: *Charles Pachter: Selected Works*, Pachter Hall, Toronto.

2006

June–September: *Regarding the Lake*, Orillia Museum of Art & History, Orillia, Ontario.

2007

January: *Des Regards sur L'Inde*, Alliance Française, Delhi, India.

January: *Glimpses of India*, Canadian High Commission, Delhi, India.

April: Art of Nature Green Living Show, Toronto.

October 7, 2007–February 8, 2008: *Charles Pachter's Canada (II)*, Royal Ontario Museum, Toronto.

Ducks Redux, The Ice House, Lake Simcoe, Ontario.

2008

April–June: *Drawing Conclusions*, McMichael Gallery, Kleinburg, Ontario.

April–June: Arena: *The Art of Hockey*, Art Gallery of Nova Scotia, Halifax, Nova Scotia.

October–December: *Canadian Icons*, University of Toronto Art Centre, Toronto.

2009

May–June: *Mythologies: Paintings 1964–2008*, Elmwood Spa, Toronto.

July–October: *The Journals of Susanna Moodie: Poems of Margaret Atwood Illustrated by Charles Pachter*, McMichael Canadian Collection, Kleinburg, Ontario.

September–October: Coldwater Gallery, Coldwater, Ontario.

October–December: *Janusz Dukszta Portraits*, University of Toronto Art Centre, Toronto.

2010

February–March: Mountain Galleries, Whistler, British Columbia.

June–August: Luminato, Toronto Roots and Four Seasons Hotel, Toronto.

2011

January–March: The University College Collection, University of Toronto Art Centre, Toronto.

June–October: *PlayNation*, Design Exchange, Toronto.

July–October: *Royal Portraits*, Beaverbrook Museum, Fredericton, New Brunswick.

July–August: *The Pachter Factor*, The Art Space, Huntsville, Ontario.

2012

May–October: 1812: *The Art of War*, Moose Factory Gallery, Toronto.

June 9–23: *Monarchs of the North*, Blue Mountain Foundation for the Arts, Collingwood, Ontario.

September 8–31: *Charles Pachter: Selected Works*, Train Station Gallery, Brantford, Ontario.

September–December: *Cinematic: Cinema-Themed Graphics*, Hyatt Regency, Toronto.

2013

The Art of War, Fort York National Historic Site, Toronto.

April–June: *A-R-T, The Art of Charles Pachter*, Art Gallery of Sudbury, Sudbury, Ontario.

July–August: *Landmarks*, Orillia Museum of Art and History, Orillia, Ontario.

November 1–30: *Pop Goes Canadiana: Iconic Art by Charles Pachter*, Enterprise Square Galleries, University of Alberta, Edmonton, Alberta.

November 30, 2013–January 10, 2014: *The Snow Show*, Michael Gibson Gallery, London, Ontario.

2014

June–August: *Lest We Forget: Sixteen paintings commemorating the First World War*, Lieutenant-Governor's Suite, Queen's Park, Toronto.

October: Oeno Gallery, Prince Edward County, Ontario.

December: Michael Gibson Gallery, London, Ontario.

2015

April–May: The Spoke Club, Toronto.

September–October: Alliance Française, Toronto.

2016

August–September: *The British Loyalist Legacy and the Creation of Modern Canada*, The Charterhouse, London, England.

December 17: Pachter and Margaret Atwood perform as guest Cannon Dolls in the National Ballet of Canada's *Nutcracker*.

2017

April–June: "What Makes This Country Tick": *Selected Works by Charles Pachter*, PAMA Peel Art Museum and Archives, Brampton.

May–June: *CHARLES PACHTER, the Cranbrook Years*, Art Gallery of Windsor.

ACKNOWLEDGEMENTS

I wish to thank the following individuals: Margaret Atwood, Rosie Abella, Rick Salutin, Marc Côté, Michael Marrus, John Lownsbrough, John Macfarlane, Anne Golden, Kathy Hogan, Judy Stoffman, Virginia Margolius Solomon, Karen Ross, John Fraser, Monika Merinat, Ann Hutchison, Marci McDonald, James Carley, Eti Greenberg, Joanne Tod, Deanna Horton, David Staines, Howard Cohen, Rick Hiebert, Ron Soskolne, Tom Smart, Cathy Burrows, Nona Heaslip, Katerine Letourneau, Merike Weiler, Irene Szylinger, Bruce Kidd, Marilyn Lightstone, Marcia McClung, Don Tapscott, Moses Znaimer, Lisa Balfour Bowen, Don Ferguson, Susan Crean, Dorothy Davey, Barb Kingstone, Murray Ball, Jane Smith, Joanne Cutler, Anne Fotheringham, Alix Arnett, Lorie Waisberg, Ginny Bellwood, and Stan Epstein for allowing me to interview them; Natalya Rattan for guiding me through the Thomas Fisher Rare Book Library; Marci McDonald, Charles Pachter, and especially Dominic Farrell for their advice and editing skills.

Thank you also to Kirk Howard for believing in me and commissioning this book, Kate Unrau for copyediting it, and Elena Gwynne for creating the index.

NOTES

Appreciation

1. Alice Munro, *Lives of Girls and Women* (Toronto: McGraw-Hill Ryerson, 1971).

Introduction

1. Margaret Atwood to Charles Pachter, 25 October 1996, Charles Pachter Papers, MS coll. 404, box 1, Thomas Fisher Rare Book Library.

Chapter 1: Childhood

1. Brock Media Release, 4 October 1996, Pachter MSS, MS coll. 404, box 4.
2. Charles Pachter to parents, 2 July 1953, Pachter MSS, MS coll. 355, box 1.

Chapter 3: Blossoming Out

1. Heinz Warschauer to Charles Pachter, 13 June 1953, Pachter MSS, MS coll. 355, box 1.
2. Charles Pachter to Heinz Warschauer, 7 May 1976, Pachter MSS, MS coll. 404, box 2.
3. Rick Salutin to Charles Pachter, 7 October 1965, Pachter MSS, MS coll. 404, box 2.
4. Rick Salutin to Charles Pachter, 13 October 1965, Pachter MSS, MS coll. 404, box 2.

Chapter 6: A Different Journey

1. Charles Pachter to Ed Roman, 20 November 1962, Pachter MSS, MS coll. 355, box 2.

Chapter 7: Graduate Studies

1. Margaret Atwood to Charles Pachter, 16 April 1962, Pachter MSS, MS coll. 355, box 4.
2. Charles Pachter to Margaret Atwood, 8 December 1964, Pachter MSS, MS coll. 404, box 1.
3. Margaret Atwood to Charles Pachter, 12 December 1964, Pachter MSS, MS coll. 355, box 4.
4. Margaret Atwood to Charles Pachter, 16 January 1965, Pachter MSS, MS coll. 355, box 4.
5. Charles Pachter to Margaret Atwood, 16 February 1965, Pachter MSS, MS coll. 404, box 3.
6. Margaret Atwood to Charles Pachter, 24 February 1965, Pachter MSS, MS coll. 355, box 4.
7. Margaret Atwood to Charles Pachter, 18 July 1965, Pachter MSS, MS coll. 355, box 4.
8. Charles Pachter to Margaret Atwood, 1 June 1966, Pachter MSS, MS coll. 355, box 3.
9. Margaret Atwood to Charles Pachter, 24 October 1966, Pachter MSS, MS coll. 355, box 4.
10. Margaret Atwood to Charles Pachter, 27 March 1967, Pachter MSS, MS coll. 355, box 4.
11. Margaret Atwood to Charles Pachter, 27 July 1967, Pachter MSS, MS coll. 355, box 4.

Chapter 8: A New Start

1. Margaret Atwood to Charles Pachter, 28 December 1968, Pachter MSS, MS coll. 355, box 4.
2. Dennis Lee to Charles Pachter, 29 September 1969, Pachter MSS, MS coll. 404, box 2.

3. Margaret Atwood to Charles Pachter, 21 April 1971, Pachter MSS, MS coll. 355, box 4.
4. *Calgary Albertan* article, 21 February 1970, Pachter MSS, MS coll. 404, box 2.
5. Charles Pachter to Angela Bowering, 15 February 1972, Pachter MSS, MS coll. 404, box 1.
6. Charles Pachter to Angela Bowering, 28 April 1972, Pachter MSS, MS coll. 404, box 1.

Chapter 9: Canada Rediscovered

1. Col. C.P. Marriott to Charles Pachter, 19 June 1973, Pachter MSS, MS coll. 355, box 11.

Chapter 10: Ten Loft Years

1. *The Ugly Show*, 15 June 1975, Pachter MSS, MS coll. 355, box 10.
2. *Globe and Mail* article, 24 September 1977, Pachter MSS, MS coll. 355, box 4.

Chapter 14: Recession and Comeback

1. *Toronto Sun* article, 30 November 1980, Pachter MSS, MS coll. 355, box 15.
2. Charles Pachter's Gracie's note, 1 May 1982, Pachter MSS, MS coll. 355, box 15.

Chapter 16: *L'Artiste et la France*

1. Margaret Atwood to Charles Pachter, 1 December 1992, Pachter MSS, MS coll. 404, box 1.

INDEX

Page numbers in *italics* mark the locations of photos or artworks.